MASTERING
EXPOSURE

D1191268

DAVID NIGHTINGALE

MASTERING
EXPOSURE

All you need to know to take perfect photos with any camera

First published in the UK in 2014 by:
ILEX
210 High Street
Lewes
East Sussex
BN7 2NS
www.ilex-press.com

Distributed worldwide (except North America)
by Thames & Hudson Ltd., 181A High Holborn,
London WC1V 7QX, United Kingdom

Copyright © 2014 The Ilex Press Limited

PUBLISHER: Alastair Campbell
EXECUTIVE PUBLISHER: Roly Allen
ASSOCIATE PUBLISHER: Adam Juniper
ART DIRECTOR: Julie Weir
EDITORIAL DIRECTOR: Nick Jones
SENIOR SPECIALIST EDITOR: Frank Gallaugher
SENIOR PROJECT EDITOR: Natalia Price-Cabrera
ASSISTANT EDITOR: Rachel Silverlight
IN-HOUSE DESIGNER: Kate Haynes
DESIGN: TwoSheds Design
COLOUR ORIGINATION: Ivy Press Reprographics

Any copy of this book issued by the publisher is
sold subject to the condition that it shall not by
way of trade or otherwise be lent, resold, hired
out, or otherwise circulated without the publisher's
prior consent in any form of binding or cover other
than that in which it is published and without a
similar condition including these words being
imposed on a subsequent purchaser.

British Library Cataloguing-in-Publication Data
A catalogue record for this book is available from
the British Library.

ISBN 978-1-78157-974-9

All rights reserved. No part of this publication
may be reproduced or used in any form, or by
any means – graphic, electronic, or mechanical,
including photocopying, recording, or information
storage-and-retrieval systems – without the prior
permission of the publisher.

Printed and bound in China

10 9 8 7 6 5 4 3 2 1

CONTENTS

INTRODUCTION

In principle, exposure is a straightforward topic. You measure the available light and then choose a combination of aperture, shutter speed, and ISO that will capture the scene as faithfully as possible, or, if you want to take a more artistic view, to capture it in a way that matches your creative intentions. But if you're just getting started with photography, you'd be forgiven for thinking that setting the correct exposure is problematic. One of the main reasons for this is that most camera manufacturers have a vested interest in promoting the belief that exposure is a deeply complex and troublesome issue, one that can only be truly solved by using their ever-more sophisticated technology (different metering modes, autoexposure options, dynamic range optimization, and so on). This is not the case. In fact, as you'll see as you work your way through this book, many of these automated and supposedly "intelligent" features are, in fact, quite a hindrance.

The problem here is a simple one. There are clearly exposures that are wrong—for example, ones that are massively under- or overexposed to the point where the subject is no longer recognizable. But there's no such thing as a "correct" exposure for any given scene. Different combinations of aperture, shutter speed, and ISO will produce vastly different images, as will lightening or darkening an exposure. For example, deliberately underexposing a shot by two stops to create an intentional silhouette of your subject, offset against a vibrant and dramatic sunset is correct, but so is overexposing the same shot by two stops to create a backlit portrait. Both shots look very different, but neither is wrong. In this context, "correct" is the extent to which the image you capture matches the image you intended to create, and it's this intentionality that's crucial. A camera doesn't intend anything—it can't see the world, at least not in any meaningful way,

and it can't make creative decisions of its own—it just uses a set of rules and algorithms to derive a best-guess exposure.

Admittedly, if you're a novice photographer, automatic metering and exposure systems can make the difference between getting a shot and missing it completely. Likewise, the better the camera, the better these systems will be: shooting in Auto using a high-end DSLR will almost always produce better results than you could get using a point-and-shoot or camera phone. But despite the fact that these cameras are often capable of making great split-second decisions on exposure, focus, white balance, and so on—often better decisions than you might make when you're first starting out—they don't always produce a great result. If we return to the example I used above—shooting a silhouette or a backlit portrait—your camera will probably capture something that falls midway between the two. This will be technically correct—there will be detail in both your subject's face and the sky—but the sky will appear washed out and overly bright while your subject's face will be too dark. Technically correct, but a complete disaster from a creative or aesthetic point of view.

The best way to address this problem is to set the exposure yourself: pick the aperture, shutter speed, and ISO that are most appropriate for the image you want to create. Along the way you'll need to learn more about how your camera meters the scene—why it sometimes gets it wrong, and how to evaluate your exposures once you've taken the shot—and you'll also need to develop a good understanding of how different apertures and shutter speeds can affect the appearance of your images as well as altering the exposure, but once you do you'll be able to create images that reflect your creative intentions, not just the technical capabilities of your camera.

CHAPTER 1

TECHNICAL CONSIDERATIONS

"There is only you and your camera. The limitations in your photography are in yourself, for what we see is what we are." —Ernst Haas

A photographer went to a dinner party and took along some of his favorite photographs. The host looked through them and said, "These are great, you must have a fantastic camera!" The photographer didn't comment, but when leaving the party he shook his host's hand and said, "That was a great meal, you must have some fantastic pots and pans!"

The moral of the story is an obvious one—great photographs are created by great photographers, not great cameras—but this doesn't mean that the tools of the trade are irrelevant. Far from it. The difference between a good cook and a bad one is that a good cook knows how to prepare the ingredients, how best to combine them, and how best to cook them. The net result is a great meal. A bad cook might throw them in the pot and hope for the best.

And it's the same for photography: A good photographer understands the tools of the trade—the nature of light, how to measure it, and how best to capture it by manipulating an exposure to create a technically and aesthetically optimal image. This opening section is geared toward providing you with the same understanding.

CAMERAS & EQUIPMENT

What type of camera do you need? Compact camera or DSLR?

In the early days of digital photography, price and quality were closely related—the more you spent on a camera, the better the images it would produce—but as technology has advanced, and production costs have decreased, this is no longer the case. For example, even the most basic of DSLRs now produce images that are far superior to the high-end professional cameras I was shooting with less than ten years ago, and they're a fraction of the cost. By the same token, most reasonably priced compact cameras will produce images that would have been considered revolutionary no more than a few years ago. In terms of image quality, then, you don't need to spend a fortune in order to create a good photograph, and you'll be able to create great images with either a compact camera or a DSLR (or equivalent). That said, the major advantage of choosing a DSLR over a compact camera is that the body is independent of the lens. With a compact camera, you're stuck with either a specific focal length (Sony's RX1, for example) or with a zoom lens that has a limited aperture range. With a DSLR, on the other hand, you will have a wide range of lenses to choose from, which can open up a range of creative possibilities that simply can't be matched by even the best compact cameras. If you're serious about developing your photography, a DSLR or equivalent will prove to be a much better choice.

Megapixels and sensor size

Back in 1999, I borrowed a Kodak DC50, a 0.38-megapixel (MP) camera (that's just 756px x 504px) with only very limited control over the shutter speed, no aperture, ISO or white balance control, and poor autofocus. Even at the time, it seemed like a piece of junk, and I was one of those shortsighted people who thought that digital photography would never catch on. Just 15 years later and things have clearly changed, and one of the biggest changes is that the resolution of even relatively basic cameras now exceeds that of 35mm film. The Nikon D800 can produce 36MP images—almost 100 times the resolution of the DC50—and even the most basic of digital cameras produce images in excess of 12MP and often a lot higher. In some ways, then, more is clearly better.

But the number of megapixels your camera can shoot is only part of the story; of equal importance is the size of the sensor. We'll look at this in a lot more detail in a later section, but the short version is that larger sensors, generally speaking, will produce better images than smaller sensors. For example, an image from a 16MP full-frame DSLR will always be better than the same resolution image from a camera phone as larger sensors are generally much more accurate because each individual pixel is a lot larger, i.e. they produce images with a better tonal range, less noise, more accurate color, and so on.

Metering modes

As you'll see as you work your way through the subsequent sections in this opening chapter, determining a correct exposure involves being able to accurately assess and measure the brightness of a scene. As such, it's worth checking out the metering options of any camera you're thinking of purchasing. All cameras have some form of metering, but you'll find it useful if you can switch to either center-weighted or spot metering. The former allows you to base the exposure on the central portion of the frame while the latter allows you to precisely measure somewhere between one and five degrees of the angle of view (see the Exposure and Metering section for more details).

← So-called point-and-shoot cameras are characteristically simple to use, offering fully automated features as well as any number of preset settings for photographing at night, or taking portraits, landscapes, sports, snow, or beach scenes. However, an increasing number of compact cameras also feature manual modes that allow users to set exposure, ISO, image size and format, and a number of other parameters. These manual overrides allow for greater user input and creativity.

→ The most versatile type of camera for "extreme" photography is a digital SLR that gives you full control over the aperture and shutter speed, as well as letting you use a wide range of lenses and accessories.

← Compared with DSLRs, compact system cameras (CSCs) are a relatively new camera format. These cameras lack the reflex mirror (and therefore the optical viewfinders) of a DSLR, allowing for a much smaller camera body. Instead of an optical viewfinder, users compose images either through an electronic viewfinder or via an LCD screen—some models only have the latter—making them closer in this respect to compact or bridge cameras. Unlike compact and bridge cameras, however, CSCs have sensors close in size or as large as the majority of DSLRs, therefore enjoying all the advantages in image quality this brings.

Lenses

One of the major benefits of buying a DSLR or equivalent rather than a compact camera is that you can change the lens. This gives you a high degree of control over two important factors: focal length and aperture (the size of the hole through which light passes). Focal length, which is measured in millimeters and refers to the optical distance between the point where light rays converge within a lens to the focal plane of the camera (its sensor), determines the angle of view. For example, a 50mm lens gives a field of view that is very similar to the human eye. Wide-angle lenses—those with a shorter focal length than 50mm—give a wider field of view, while telephoto lenses (those that are longer than 50mm) give a narrow a field of view.

While focal length is clearly a crucial factor in choosing a lens, a more significant factor, for the purposes of this book at least, is the aperture range of any given lens, particularly in terms of its maximum aperture. As you'll see in a subsequent section, lenses with a large maximum aperture present you with a much wider range of options, both in terms of controlling exposure and depth of field (the amount of an image that's in focus versus how much is blurred).

The bad news is that lenses with wide maximum apertures are often much more expensive. For example, Canon's kit lens—the 18–55mm midrange zoom for their crop-sensor DSLRS—has a maximum aperture of between $f/3.5$ (at 18mm) and $f/5.6$ (at 55mm), while their 24–70mm L lens—a lens that covers the same focal range for their full-frame DSLRs—has a consistent maximum aperture of $f/2.8$. This is only marginally bigger than $f/3.5$, and two stops bigger than $f/5.6$, yet the lens costs over 17 times the price.

As well as being much more expensive, lenses with a bigger maximum aperture can be larger than an equivalent lens with a smaller aperture, but as you'll see as you work through the remainder of this book, they do provide you with a range of creative opportunities that simply aren't possible with cheaper lenses.

Zoom versus prime lenses

On the face of it, zoom lenses—ones that allow you to vary the focal length—seem to provide a much better alternative to lenses with a fixed focal length insofar as they allow you to capture a range of images that simply wouldn't be possible using a single focal length. But this convenience comes with a price: they're often heavier and bulkier, as they have more components within the lens, they're more expensive to produce, not as sharp, and often don't have as large a maximum aperture as their fixed focal counterparts.

For example, one of the best, most affordable, and lightest lenses that most manufacturers produce, and one that also has a large maximum aperture, is the 50mm prime. Canon's, for example, has a maximum aperture of $f/1.8$ yet it's the cheapest lens they produce. So if you only have a kit lens but decide that you'd like to explore shooting at wider apertures, this lens would be a great first choice for your second lens.

Focal length

Any lens can be used to shoot any subject, but generally speaking, some focal lengths are better suited to specific subjects. For example, if you're interested in shooting landscapes then you'll find a wide-angle lens much more useful than a telephoto as it will allow you to capture a much broader view. Likewise, if you're into nature photography or sports photography, being able to get closer to the action with a longer focal length lens will often prove invaluable.

← This is a typical consumer kit zoom ("kit" meaning it came as a package deal with the camera purchase). They are capable of taking excellent images, but only when used correctly, and the ways they can be used incorrectly are numerous—largely related to their limited aperture range. This one starts at f/3.5 at the wide end and closes all the way down to f/5.6 by the time it gets to telephoto.

← As you develop your photography, it's natural to want more and more lenses to fulfill every possible shooting desire. It can be downright intimidating. But learning to work within the limits of your given tools is far more useful to developing your shooting skills than amassing a huge collection of lenses. There aren't any bad lenses anymore, anyway—the technology is too highly evolved. There are only good lenses and exceptionally good lenses. You can't go wrong!

↑ This lens is called a fixed focal length or prime. As opposed to the limited kit zoom, this lens' aperture opens all the way to f/1.8, which gives a huge amount more freedom in exposure and composition. The trade-off, of course, is that it has exaclty one focal length. Want to zoom in? You have to get closer!

EXPOSURE: AN INTRODUCTION

At its most basic, exposure is a very straightforward concept—it's all about making sure the right amount of light reaches your camera's sensor. There are a variety of ways this can be achieved, which we'll look at shortly, but let's first take a quick look at why we need to understand this process.

How is an image captured digitally?

In many ways, a digital camera's sensor operates in a similar way to the human visual system. Just as photons strike the retina in the human eye, so photons are collected by photosites on a sensor (rather like water drops falling into a bucket). In both cases, the resulting signal is sent to be processed—either by the camera's internal processor or the human brain—and the end result is an image.

Aside from the electronics involved in a camera, there is one significant difference between the two processes: The eye continually adjusts to varying levels

of brightness, whereas the light sensitivity of a camera's sensor is fixed during the period of exposure. So, in order to get the exposure "right" we need to make sure that the right amount of photons hit the sensor in order to accurately represent the scene. If there are too few photons, the scene will appear dark in the final image, but too many and it will appear overly bright.

To make things slightly more complicated, each photosite has a limited capacity, so it can only record a certain number of photons before it becomes full. When it reaches its capacity, it will output exactly the same signal each time (pure white in the image), irrespective of how many further photons strike it during an exposure—just as a bucket with a five-gallon capacity can only ever hold five gallons of water, regardless of how much water is consequently poured into it. Fortunately, to check the exposure all you need to do is assess the histogram on your camera's LCD display once you've taken a shot.

→ 90mm, 1/1000 second,
f/8, ISO 200
Getting the exposure right is a matter of both hitting your target (the right exposure variables for the given amount of light) and also creative judgment (if all the tones can't fit on the sensor, which are more important, the highlights or the shadows?). It's a lot to keep in your head at first, but like most things, practice makes perfect.

→→ 200mm, 1/3200 second,
f/5.6, ISO 100
An ultra-short shutter speed and wide aperture has frozen the movement of the waves, but this is just one possible exposure combination. A longer shutter speed and smaller aperture would have delivered the same exposure overall, but the result would be totally different.

A histogram is the most accurate exposure guide, whether you use the histogram on your camera or in an image-editing program. The histogram shows shadow detail at the left, mid-tone detail in the middle, and highlight detail to the right.

A correctly exposed image will usually have a good distribution of tones across the range, whereas an underexposed image will contain relatively little highlight detail and the shadow tones will often be bunched to the left. If the histogram hits the left edge of the scale, this indicates that no data has been collected in the darkest areas, and these will appear black in the final image.

With an overexposed image, the opposite happens—the histogram will be skewed to the right. If it hits the right edge, this means some photosites have received too much light and are completely full. These will appear as pure white pixels in the final image.

CORRECTLY EXPOSED

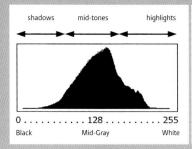

UNDEREXPOSED

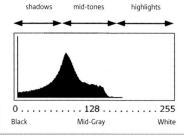

OVEREXPOSED

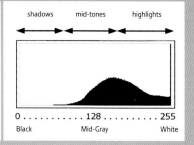

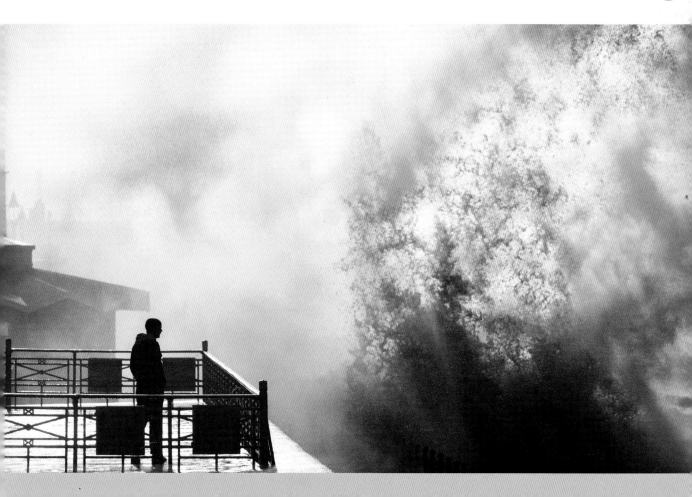

EXPOSURE VALUE

A term intrinsically linked to exposure is EV (short for Exposure Value), which relates to light intensity. An EV of 0 is the intensity of light required to correctly expose a neutral, 18% gray card (the default target for an exposure meter), using a 1-second exposure, an aperture of $f/1$, and a sensitivity setting of ISO 100. All other EVs are determined from that, ranging from EV -6 (a starlit night sky) to EV +20 (bright, specular highlights).

Take it step by step

An EV step increase or decrease is a doubling or halving of the light intensity, so EV 2 is twice as bright as EV 1, and half as bright as EV 3, for example. In terms of real-world exposures, an EV step is the same as adjusting the shutter speed, aperture, or ISO by one full stop. For example, a cloudy, bright scene will be around EV 13, which could be exposed at 1/125 second, $f/8$, at ISO 100. However, if the cloud thickened, the EV would drop to 12. To compensate for this you could either increase the shutter speed by one stop (to 1/60 second), open up the aperture by one stop (to $f/5.6$), or raise the ISO by one stop (to ISO 200). Either one of these would compensate for the decrease in the light intensity, but, as we will see on the following pages, each of these fundamental exposure controls will affect the image in a different way.

So, there are ultimately two key factors that contribute to determining an exposure. The first of these is the EV of the scene—the amount of light reflected from the scene you are photographing—and the second is the combination of aperture, shutter speed, and ISO needed to allow sufficient light to reach your camera's sensor. The key thing to remember is that while the EV constrains the camera settings (in that you need to select a particular aperture, shutter speed, and ISO combination to get the right exposure), it doesn't actually determine any of the individual values. The same scene can be recorded using a wide range of apertures (providing the shutter speed and ISO are set accordingly), an equally wide range of shutter speeds (with a corresponding adjustment aperture and ISO), and a choice of ISO settings (again assuming the aperture and shutter speed are set to keep the overall exposure balance). In this sense, any scene—no matter how bright, or how dark—offers a huge range of photographic possibilities, from the safe, to the extreme. And that is precisely where the skill of the photographer comes into the equation.

↓ 1/160 second, $f/16$, ISO 100
Night-time skyline: EV -1

→ 1 second, $f/5$, ISO 50
Bright sunlight and snow: EV 16

This list is a guide to illumination levels and their corresponding Exposure Value (EV) at an ISO 100 sensitivity setting. Each EV step increase means the intensity of the light doubles, while each single EV decrease means the light intensity is halved. This relates directly to a "stop" in terms of the aperture, shutter speed, or ISO. Remember, the type of measurement doesn't matter—it's all light to the final image, whether you're measuring it in f/stops, shutter speed, or ISO sensitivity.

The goal here isn't to memorize the exact Exposure Values for each of these scenarios (though with time you may end up doing just that, out of habit). Rather, it's more helpful to remember the order and hierarchy of these shooting situations. Just remembering that bright, overhead sunlight is so much brighter than a home interior can be helpful enough to remind you that a slight ISO boost, to say, 400, is probably a good idea. It's hard to remember just how dramatic the difference in brightness is between these situations, because our eyes are so effective at presenting a consistently well-exposed scene.

EV	Typical subject
-6	Starlit night sky
-5	Crescent moonlight, faint aurora
-4	Quarter phase moonlight, medium intensity aurora
-3	Full moonlight, bright aurora
-2	Full moon light on a snowscape
-1–+1	Night-time city skylines (varying intensity of light)
+2	Distant lit buildings (at night)
+3–5	Indoors, low light
+6–7	Home interior
+7–8	Bright street scenes, dawn and twilight
+9–11	Just before sunrise or just after sunset
+12	Heavily overcast, or open shade with sunlight
+13	Cloudy, bright with no shadows
+14	Hazy sunlight with soft shadows, or bright sun low in sky
+15	Bright sunlight overhead with sharp shadows
+16	Bright sunlight on snow or light sand
+17–20	Specular sunlight reflections, intense man made lighting

THE EXPOSURE TRIANGLE

As we discussed in a previous section, obtaining a correct exposure, at its simplest, is about ensuring that the right amount of light reaches your camera's sensor. You need to pick an appropriate aperture, shutter speed, and ISO that when combined will ensure that your image is correctly exposed. We'll be taking a much more detailed look at each of these settings in subsequent sections but, for the time being, it's worth briefly summarizing how each of these settings changes the final exposure.

The exposure variables

The aperture, as we'll discuss in more detail in the next section, is the size of the opening through which the light passes on its journey to your camera's sensor. The bigger the opening, the more light gets through, and the brighter the resultant image will be. Conversely, a smaller aperture allows less light to get through, so the exposure will be darker. Shutter speed refers to the amount of time the shutter remains open. Longer shutter speeds allow more light to reach the sensor— the exposure will be brighter—while shorter shutter speeds allow less light to get through so the exposure will be darker. ISO, unlike aperture and shutter speed, doesn't vary the amount of light reaching the sensor, but it does have a direct impact on your exposure. Increasing the ISO brightens the final image, while lowering it will darken an image.

When combined, these three settings are often referred to as the Exposure Triangle (or Photographic Triangle)— the three key settings that determine the brightness of each and every exposure you take—and as we have seen, varying any of these settings has a direct effect on exposure: the exposure gets brighter, or it gets darker. For example, if you're shooting a scene in bright daylight at $f/16$ (a small aperture), with a shutter speed of 1/100 second at ISO 100, and you open up the aperture to $f/11$ (one stop bigger) you will allow twice as much light to reach the sensor. The resultant image will be brighter. Alternatively, if you close down the aperture by one stop to $f/22$ only half as much light will reach the sensor. The image will be darker. The same can be done by varying the shutter speed, or by varying the ISO.

↓ 1/250 second, $f/10$, ISO 100, multi-shot panorama
There are pluses and minuses to each exposure variable. If you have a tripod, the longer shutter speeds mean narrower apertures can be employed. If you have a wide-aperture lens, shorter shutter speeds can be used. It's a matter of balancing what you need for your shot with what you have at your disposal.

For any given exposure, though, it's possible to vary the settings but maintain an equivalent exposure, i.e. despite using different settings each image will be equally as bright as the last. To do this you need to vary two or more of the settings, not just one. For example, if you were shooting at ISO 100 with a shutter speed of 1/100 second at $f/16$ but then changed the shutter speed to 1/50 second and the aperture to $f/22$, both exposures would be identical. The reason for this is because the change in shutter speed doubles the amount of light reaching the sensor, but closing down the aperture by one stop (from $f/16$ to $f/22$) halves it. In short, exactly the same amount of light reaches the sensor in both cases.

At first, this may seem complicated—how are you supposed to know that $f/4$ at 1/5 second at ISO 200 is the same exposure as $f/8$ at 1/10 second at ISO 1600? But it's this principle that will form the basis of every decision you make regarding the settings you choose to capture a shot. Let's take a look at an example that should help to clarify this point.

Imagine that you're shooting a wedding in a dark church (with an EV of 4) and you want to capture the exchange of rings. One possibility would be ISO 100 at $f/2.8$ with a half-second exposure. These settings will ensure a correct exposure at EV 4 but clearly, a half-second exposure won't work—it's far too slow to capture the movement in the scene. In this instance, you can't open up the aperture (f2.8 is the maximum aperture of the lens you're using at the time), so in order to increase the shutter speed you'll also need to increase the ISO. For example, if you increase the ISO to 1600 you brighten the image by four stops (100 to 200, 200 to 400, 400 to 800, and 800 to 1600) so you can now increase the shutter speed by the same amount—1/2 to 1/4 second, 1/4 to 1/8 second, 1/8 to 1/15 second, and 1/15 to 1/30 second—a speed that's just fast enough to capture this important moment. If you wanted to play it safe, you could further increase the ISO to 3200—one additional stop—which would allow you to also increase the shutter speed by one stop, i.e. from 1/30 second to 1/60 second. The key point to note is that the relationship between each of these settings is reciprocal such that if you wish to change the aperture, shutter speed or ISO while simultaneously maintaining a specific exposure, you need to change two of the settings by equal EV intervals, as we did above, or all three in such a way that the exposure remains constant.

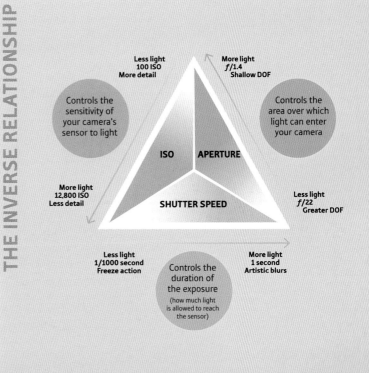

THE INVERSE RELATIONSHIP

Less light
100 ISO
More detail

More light
$f/1.4$
Shallow DOF

Controls the sensitivity of your camera's sensor to light

Controls the area over which light can enter your camera

ISO APERTURE

More light
12,800 ISO
Less detail

Less light
$f/22$
Greater DOF

SHUTTER SPEED

Less light
1/1000 second
Freeze action

More light
1 second
Artistic blurs

Controls the duration of the exposure
(how much light is allowed to reach the sensor)

CONTROLLING EXPOSURE: APERTURE

The aperture is a hole inside a lens that can be varied in size to regulate the amount of light reaching the camera's sensor. A larger aperture allows more light to reach the camera's sensor, while a smaller aperture allows less light—it's that simple! However, once we start to look at it in more detail, things get slightly more complicated.

ƒ/stops

The most common way to reference the size of the aperture is in f-stops, such as $f/2.8$, $f/8$, $f/16$, and so on, with a smaller number somewhat counter-intuitively indicating a larger aperture. This is because f-stops are written as the ratio of the focal length of the lens to the maximum size of its aperture. For example, if a 50mm lens had an aperture measuring 50mm in diameter it would have a maximum aperture of $f/1$ (50/50). However, if the maximum size of the aperture was 25mm, the maximum f-stop would be $f/2$ (50/25). Drop the size of the aperture to 12.5mm and the maximum $f/$stop becomes $f/4$ (50/12.5), and so on.

Now, just to confuse things, an aperture of $f/2$ is not half the size of an aperture of $f/1$—it is a quarter of the size. Although the diameter of the aperture has been halved, the area of the hole has actually been quartered. Therefore, an aperture of $f/1$ allows four times as much light to reach the sensor as an aperture of $f/2$, and $f/2$ lets in four times as much light as $f/4$.

While the numbers behind the aperture can be confusing, the most important thing to remember is that each major aperture increment ($f/2.8$, $f/4$, $f/5.6$, and so on) represents a halving or doubling of the amount of light reaching the sensor. In other words, if you double the size of the aperture (open up by one stop, from $f/5.6$ to $f/4$, for example), you would need to halve your shutter speed in order to maintain the same overall exposure.

→ 25mm, 1/250 second, $f/10$, ISO 100
An aperture of $f/10$ helps keep the chains in focus, as well as ensuring the buildings in the background are sharp enough to be recognizable.

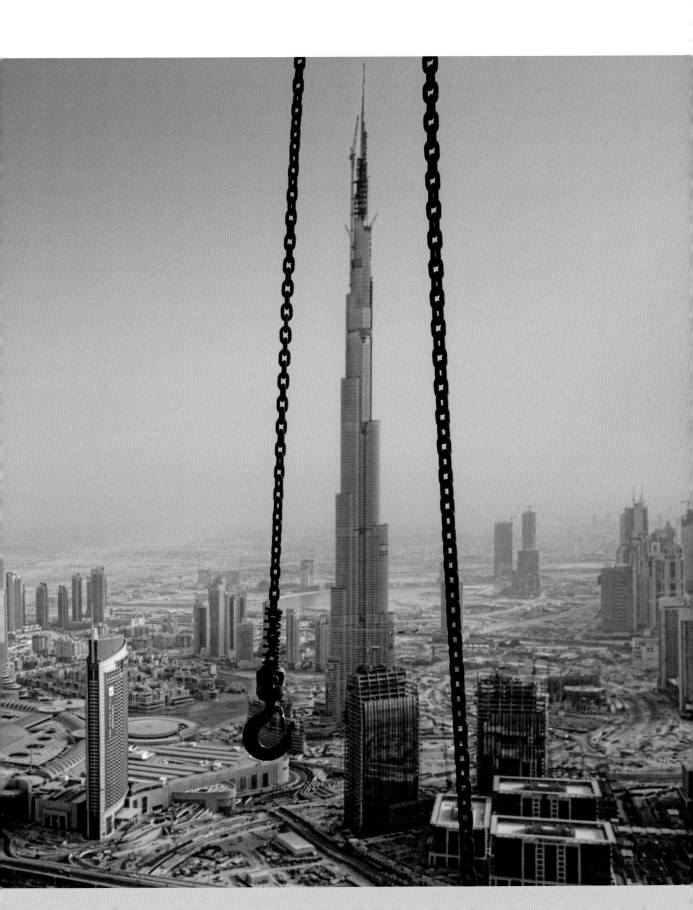

Depth of field

While the mechanical effect of varying the size of the aperture is to alter the amount of light reaching your camera's sensor, it also has another important effect—it changes the depth of field. Depth of field refers to how much of an image is in focus in relation to the point of focus. When you use a large aperture, the depth of field is shallower, while a smaller aperture will increase the depth of field. If you are shooting a landscape, for example, you might want all of the image to be in focus, from foreground to background, so a small aperture would be most appropriate. Alternatively, if you are shooting a portrait and want to isolate your subject against a blurred background, a larger aperture will provide a shallower depth of field so your subject (and little else) is in focus.

Irrespective of the aperture you use, there is one further point you should note in relation to depth of field and the focus point, i.e. that the sharply focused area of an image extends about 1/3 in front of the focal point and 2/3 behind. For example, if the focus point is set to 6 feet, and the depth of field is 1 foot, the range of focus will extend from 5 feet 8 inches through to 6 feet 8 inches. This is a topic we'll return to later when we discuss using the hyperfocal distance to maximize depth of field (see page 122).

Two further factors that affect depth of field are the focal distance, and the focal length of the lens. In terms of focal distance, the farther away from the camera that you place the point of focus, the greater the depth of field. For example, if you use a 50mm lens on a full-frame camera and focus on the horizon (infinity), everything from 95 feet (29m) from the camera to the horizon will be in focus using an aperture of $f/2.8$. However, if you focus on an object 6½ feet (2m) from the camera, using exactly the same aperture, the depth of field will only extend from 6 feet (1.9m) to 7 feet (2.1m). In other words, it's easier to produce an image with a shallow depth of field when the main object of the shot is closer to the camera.

By the same token, the focal length of the lens also has an impact on depth of field; wide-angle lenses have a much larger depth of field than telephoto lenses. For example, with a focus distance of 33 feet (10m), and an aperture of $f/2.8$, the depth of field will extend from 8 feet (2.6m) to infinity using a 17mm focal length lens on a full-frame camera, but if you switch to a 200mm telephoto lens—keeping the same focus distance and aperture—the depth of field extends from just 32 feet (9.8m) to 33½ feet (10.2m).

Previewing depth of field

When you look through a digital SLR's viewfinder, you do so at the maximum aperture of the lens you have attached to your camera. This lets as much light as possible travel through the lens, which helps when focusing, but it doesn't give you any useful feedback about the depth of field unless you are shooting at that aperture. However, most digital SLRs have a depth of field preview button that stops the lens down to the selected "taking" aperture. This lets you see the view through the aperture that will be used at the moment of image capture, so you can check the depth of field. The only problem is that smaller aperture settings let in less light, so while the preview image in the viewfinder reveals the depth of field, it will be very dark, especially at the smallest aperture setting.

← 17mm, 1/200 second, $f/11$, ISO 100
Shooting at $f/11$ with a wide-angle focal length maximizes the depth of field so everything in the frame is in sharp focus.

→ 85mm, 1/1000 second, $f/1.8$, ISO 100
On the other hand, shooting with a very wide aperture at the telephoto end of the focal range lets you pick out single planes of focus, accenting individual elements while letting others fall off into blurriness.

CONTROLLING EXPOSURE: SHUTTER SPEED

While the mechanics of the shutter are more complicated than those of the aperture, its function is similar—it regulates the amount of light reaching your camera's sensor. Most digital SLRs utilize a focal plane shutter, most often formed by a pair of mechanically operated blinds, or curtains, that open and close to regulate the duration of the exposure. When you press the shutter release the first blind opens to start exposing the sensor to light, and the second blind follows to close the shutter. For very short exposures (typically faster than around 1/250 second), the second blind starts to close before the first has finished opening, so the sensor is exposed to a fast-moving slit of light that travels across it. The faster the exposure, the narrower the slit between the two blinds.

Electronic First Curtain

Up until recently the shutters in most DSLRs were mechanical, i.e. both the front and rear curtains were physical devices that travelled across the sensor, and at the end of each exposure the image would be read from the sensor. Some current cameras, e.g. Sony's SLT range, utilize an electronic front curtain shutter (EFCS). There are two major benefits to using an EFCS. First, the shutter is quieter, and second there is less movement within the camera during an exposure thereby minimizing camera shake. The way in which an EFCS works is as follows:

1. Rather than starting an exposure by opening the shutter, a camera with an electronic front curtain shutter starts with the shutter open but then clears the data from the sensor, row by row, at the same speed as a mechanical front curtain would traverse the sensor. Immediately after clearing the existing data, each row begins a new exposure.

2. At the end of the exposure—determined by the shutter speed you have set, the second mechanical curtain closes the shutter.

3. The image is then read from the sensor.

As most digital SLRs offer a shutter speed range from 30 seconds to 1/4000 second, or 1/8000 second, it covers a much larger EV range than the aperture. But, more importantly for the creative photographer, while the aperture controls depth of field, the shutter controls motion. A short shutter duration has the potential to "freeze" a moving subject, with extremely short shutter speeds capable of recording moments in time that are simply not possible to see with the naked eye. At the opposite extreme, a longer shutter speed can introduce a sense of motion, either through camera movement or subject movement. Extremely long shutter speeds can go as far as transforming the subject, again producing an image that exceeds human vision. We'll cover this topic in much more detail at the start of the next chapter.

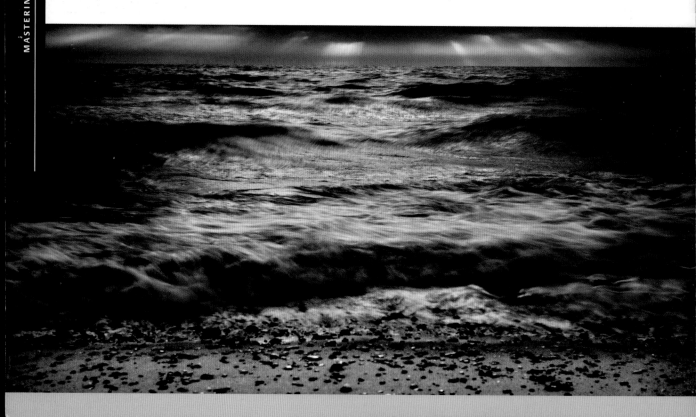

↑ 48mm, 1/4 second,
f/8, ISO 100

→ 17mm, 30 seconds,
f/11, ISO 100

← 105mm, 1/800 second,
f/5.6, ISO 100

These three shots of the
sea were taken at a variety
of shutter speeds. You can
see how a fast, 1/800 second
shutter speed freezes the
crashing waves on the right,
while a very long exposure
transforms the water into
a smooth "fog" (above).
Setting an exposure of 1/4
second (left) introduces
blur, but the waves are still
recognizable. In each case,
it's the same subject, just
photographed with a
different shutter speed.

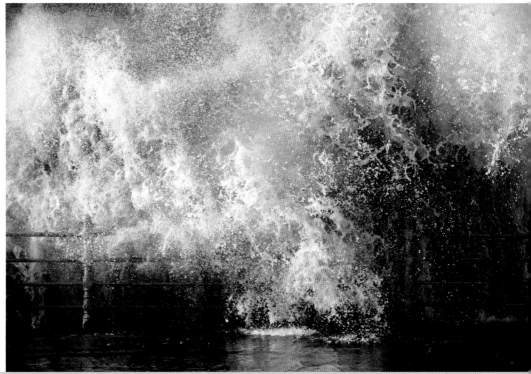

CONTROLLING EXPOSURE: ISO

Over the previous few pages we have discussed two methods you can use to vary an exposure: altering the aperture, to increase or decrease the size of the aperture through which the light passes, thereby varying the amount of light that reaches your sensor during a given exposure; and altering the shutter speed, to increase or decrease the amount of time the sensor is exposed to light.

The third way

You can use one further method, i.e. altering the ISO. Unlike the previous two methods, though, this is one that doesn't affect the amount of light reaching the sensor, rather it alters the way in which your camera responds to that light. Back in the days of film, ISO wasn't something you could set in-camera, you chose a film with a specific ISO and then loaded your camera, using a low ISO for shooting in bright light, and a high ISO when you were shooting in dimmer light. In each case, the ISO of the film was determined by the speed with which it would react to light. Faster films—ISO 800, 1600 and so on—are more sensitive to light because the grain size is larger, while slower films with smaller grain react slower.

For example, if you knew you were going to be shooting in a dim environment but needed to maintain a shutter speed of no less than 1/60 second at an aperture of $f/4$ you would know that you would need an ISO of 800 and above.

ISO	Aperture	Shutter Speed
100	$f/4$	1/8
200	$f/4$	1/15
400	$f/4$	1/30
800	$f/4$	1/60
1600	$f/4$	1/125
3200	$f/4$	1/250

You may have read that changing the ISO on a digital camera is equivalent to changing the speed of your film, i.e. that in increasing the ISO you increase your sensor's sensitivity. This is not the case.

As I mentioned at the start of this chapter, during an exposure photons are collected in the photosites on your camera's sensor. These are then counted and converted to a signal that indicates the color and brightness of each pixel. When you increase the ISO, the same number of photons reach your camera's sensor, but the signal that it generates is amplified: i.e. doubled when you increase

the ISO from 100 to 200, quadrupled when you increase it from 100 to 400, and so on.

To give you an example, shooting at ISO 100 using an aperture of 1/100 second and $f/8$ will produce an image that's equally bright as one shot at ISO 200 using a shutter speed of 1/200 second at $f/8$, i.e. both images, superficially at least, will appear identical. In the case of the ISO 200 image though, only half as much light reaches the camera's sensor, but the signal this generates is then doubled.

On the face of it, then, this is a useful technique insofar as it allows you to maintain a sufficiently fast shutter speed to capture the action, or a sufficiently small aperture to maintain adequate depth of field. For example, if the ambient light is low, indicating an exposure at ISO 100 of 1/8 second and an aperture of $f/4$, you could increase the ISO to 800 and take the shot at 1/60 second; i.e. you could shoot using natural light rather than adding flash or another source of artificial light.

As I mentioned earlier though, the way in which this works is that the signal from the sensor is amplified when you increase the ISO, and just as an audio signal can degrade when you turn the volume up too high, so too can the signal from your camera's sensor; i.e. it can introduce noise into the final image. This can take two forms: chroma noise (unexpected variance in color) and luma noise (unexpected variance in brightness).

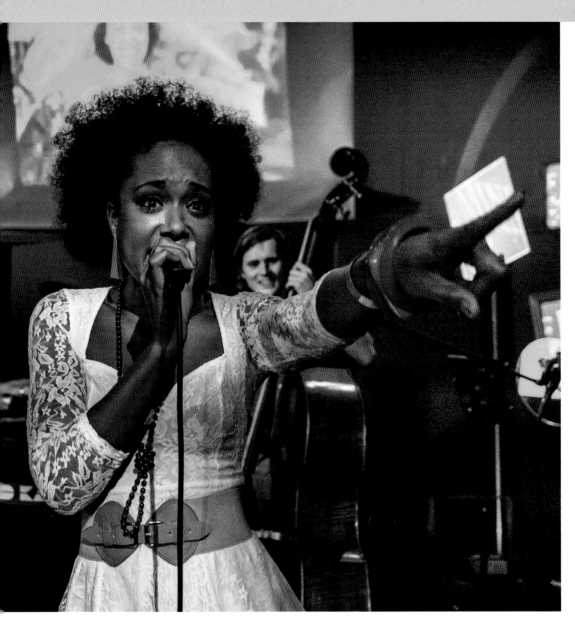

↑→ 40mm, 1/250 second, ƒ/2, ISO 3200

Concert photography is a classic case of needing fast shutter speeds in dim lighting. A fast lens, such as the ƒ/2 one used in this shot, can only get you so far. Any shutter speed lower than 1/250 second would have resulted in motion blur, and the singer's gestures and expression are the most compelling aspects of this image. Had there been more light, a lower ISO could've been used to capture more highlights and better color fidelity, but exposure is all about dealing with the hand your dealt! Even zoomed in 100%, as you can see on the right, the noise is subtle and unobtrusive—fine enough to even count the subject's eyelashes! At the end of the day, high ISOs are a sort of saving grace. By all means, keep the ISO as low as possible, but if push comes to shove, a noisy-but-sharp picture is better than a clean-but-blurry mess.

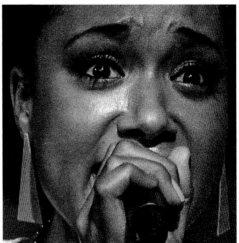

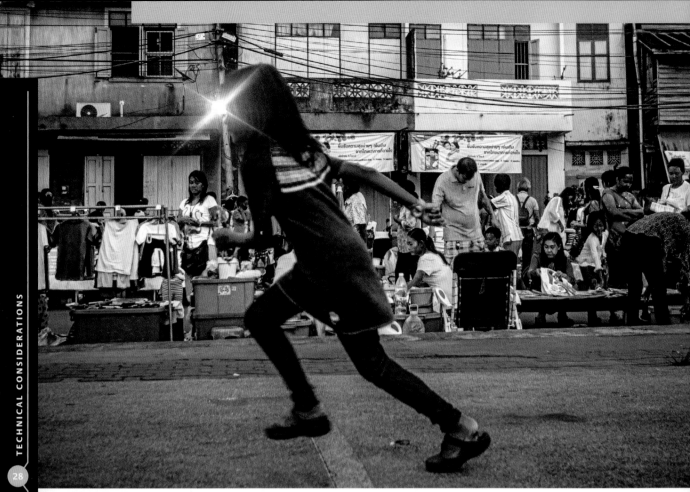

Noise

There are three sources of noise. First, all light has noise, much like static in a radio signal, but this isn't something you can see with the naked eye. This is referred to as "shot noise" and it varies in accordance with the magnitude of the light. If you have lots of light, the light to noise ratio is pretty much insignificant, but when you have less light, there is proportionally more noise. So shooting at a higher ISO cuts the amount of light that's recorded, increasing the ratio of noise to light. Of all three sources of noise, shot noise is the most significant.

The second source of noise is "read out" noise, i.e. inaccuracies in reading the voltage at each pixel. This doesn't vary with ISO, but any noise introduced at this stage is magnified proportionally as you increase the ISO. This source of noise can be minimized by slowing the read rate from the sensor, but this isn't a practical solution when you need a camera with a reasonably high frame rate.

The third source is "dark-current noise." When a photon hits the sensor it creates an electron, which is then converted to a voltage, but heat can create additional electrons thereby adding yet more noise to the system. Scientific cameras solve this problem by cooling the sensor, sometimes to as much as -100C, but this clearly isn't a practical solution for a consumer camera.

In short, then, noise is inevitable, but there are two additional factors that determine the extent to which it will be problematic: the size and the age of your sensor. Smaller sensors, particularly those in compact digital cameras, tend to produce more noise because the photosites are considerably smaller: as such, they are less accurate. Older cameras also produce more noise than newer ones. For example, the ISO range of the Canon 20D, which was released in 2004, is 100 to 3200, but ISO 3200 is almost unusable due to the high amounts of noise it generates. The Nikon D4s on the other hand—released in 2014—has an effective ISO range of 200–25,600 (and can be boosted to 409,600!). This camera will produce much cleaner images at higher ISOs than the 20D as sensor technology has advanced considerably in recent years. In each case, though, irrespective of the type or age of your camera, increasing the ISO will introduce some additional noise, and the higher the value you use, the more noise it will introduce.

In summary, when changing the aperture or shutter speed to obtain an optimum exposure is either impossible or undesirable, changing the ISO can be a viable alternative, but it will introduce at least some degree of noise.

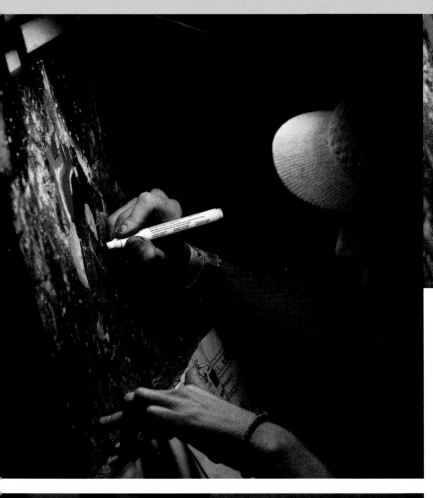

←← 40mm, 1/250 second, ƒ/5.6, ISO 1600
If you have a quality capture that you like, but which has an intrusive amount of noise, it may be worth trying out a black-and-white conversion. For one, it largely eliminates chroma noise, since there's no chroma anymore. Also, black and white has a tradition of being rougher and more textured with noise or grain, and what looks distracting in a color rendition may end up adding character to a black-and-white version.

↖↙ 40mm, 1/125 second, ƒ/2, ISO 3200
Here you can clearly see the rapid evolution of high-ISO capabilities in modern digital cameras. The picture above was taken with a 2008 Olympus E-P1, the one below with a 2013 Olympus E-M5. Both are shot at ISO 3200, in very similar dim lighting conditions. You can see that the sensor from 2008 is incapable of resolving the text on the marker, and the black background is speckled with noticeable luminance noise. The newer sensor below, on the other hand, can clearly resolve individual strands of hair, and while the shadow areas on the face still have luminance noise, it's of a much finer-grained quality that makes it much less distracting. What a difference a few years can make!

WHITE BALANCE

White balance, while not directly related to the main topic of this book, does have a profound effect upon the appearances of your images and refers to the way in which you can match the color balance of your images to color balance of the scene that you are shooting. The reason that this is necessary is because the "temperature" of light—its apparent warmth or coldness—can vary, depending on the time of day, light source, and so on. For example, candlelight and sunrise appear warm, while the light on a shady day can seem much cooler. Of equal importance is the fact that the way in which our cameras see color temperature is different to the way in which we perceive it. For example, our perception of color remains relatively constant, irrespective of the light source, while our cameras faithfully record what are often very pronounced differences—tungsten light sources appear very warm, while light on an overcast day can seem very cold.

Degrees Kelvin

Color temperature is measured in degrees Kelvin, and can seem counterintuitive at first insofar as apparently warmer colors have a colder temperature while "cooler" ones have a higher temperature. For example, candlelight is much colder than daylight. The reason for this is because color temperature is correlated to the visible radiation emitted from a "blackbody radiator" at a specific temperature. A blackbody radiator is a theoretical object that absorbs all incident light, but for the sake of convenience, you could imagine it as a large piece of metal. As this metal is warmed, it starts to glow—first, a dull red, then orange as it is heated further, through yellow, to "white hot" at even higher temperatures.

In practice, daylight, and most other light sources (e.g. tungsten bulbs) closely mimic blackbody radiators and our cameras provide us with a range of ways in which we can either match the "white balance" of the shot to the color temperature of the scene, or vary it for creative effect. For example, shooting using tungsten (or incandescent) white balance on an overcast day will add a blue cast to your images. Other light sources, fluorescent lighting for example, do not resemble blackbody radiators so white balance uses a second variable in addition to color temperature: a green-magenta shift.

There are a variety of ways in which you can control the white balance of your images. The first is that you can trust your camera to work it out for you and shoot in Auto White Balance (AWB), then correct any discrepancy when you process your Raw file. This can be an effective strategy as the white balance isn't hardcoded into a Raw file (as it is with a JPEG)—it just tags the image. As such, changing the white balance has no effect on the quality of your images so it isn't absolutely crucial you get it right as you take the shot.

Alternatively, you can pick the white balance setting that most closely matches the ambient lighting—flash, cloudy, etc.; you can choose a specific color temperature (in degrees Kelvin); or you can create a custom white balance setting for any specific scene (check your camera manual for how to do this).

A final alternative is to include a neutral reference card—often comprised of a white card, grey card, and black card—in the first shot of a sequence of images. This can then be used to set a very precise color balance during the Raw conversion process.

Color Temperature	Light Source
1000–2000 K	Candlelight
2500–3500 K	Tungsten Bulb (household variety)
3000–4000 K	Sunrise/Sunset (clear sky)
4000–5000 K	Fluorescent Lamps
5000–5500 K	Electronic Flash
5000–6500 K	Daylight with Clear Sky (sun overhead)
6500–8000 K	Moderately Overcast
9000–10000 K	Shade or Heavily Overcast

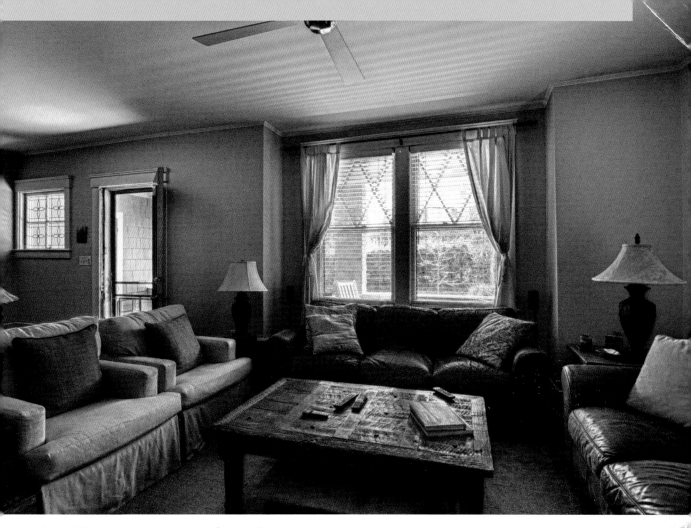

↑ 18mm, 1/800 second, ƒ/5.6, ISO 100
Shooting an interior with windows open to daylight is a classic case of mixed lighting. The tungsten-lit interior is much warmer than the cool blue sunlight of midday, and your camera's automatic white balance feature may bias too far in favor of one or the other. Shooting Raw ensures you can strike the delicate balance so the final result looks natural.

Shooting in mixed lighting

When you're shooting in mixed lighting, for example, scenes combining indoor lighting and natural lighting, choosing a correct white balance isn't possible as the scene contains elements that are lit by light sources at very different temperatures. In these circumstances, you can average out the difference using AWB, or choose to base your white balance on one source or the other. However, the difference between the two sources can seem very pronounced.

Creative versus correct white balance

Setting an accurate white balance can often be essential—for advertising photography, product photography, and so on—but for general photography it may not always be desirable. For example, if you're shooting a landscape at either dawn or dusk, the light will be much warmer than during the rest of the day. However, setting an accurate white balance will "correct" this, rendering your image much colder than expected. One solution to this is to set an accurate white balance, using any of the methods above, but then warm up the image during the Raw conversion process using the temperature slider. This adds warmth to the image that will often seem more natural than creating an image that has a "correct" white balance.

UNDERSTANDING THE HISTOGRAM

Back in the days of film, learning how to perfectly expose for any given scene was a drawn-out process. You would meter the scene, set the aperture and shutter speed, take the shot, note down the settings you used, develop the film, and then make the print, only to realize that you underexposed by at least one stop because the brightness of the scene fooled your meter. From there, you would need to remember to deliberately overexpose by one stop next time you shot a similar scene. With the advent of digital photography this learning process has been greatly accelerated as you can now preview your images as you take them, check your histogram, and then alter the exposure as necessary. That said, if you're not familiar with reading a histogram they do require some explanation.

What histograms are telling you

Put simply, a histogram describes two things: the tonal range of an image and the number of pixels at any given level of brightness. The tonal range—the range of dark to light, shadow to highlight—is described by the horizontal axis, with shadows on the left, highlights through to white on the right, while the height of the histogram indicates the number of pixels at any given level of brightness. For example, a histogram with very little data on the left, rising to a large peak in the middle, with little data on the extreme right tells you that there are very few pixels that are black, lots of mid-tone values, and few very bright highlights. A good example of an image that would have a histogram that looks something like this would be a landscape shot on a heavily overcast day.

The important thing about the histogram is that not only does it describe your data, it also allows you to accurately evaluate the effectiveness of your exposure: did you capture the scene as you intended? For example, if you're shooting a snow scene and your histogram indicates that there is no data towards the right-hand side, i.e. no bright highlights, you will know that you have underexposed and can adjust the exposure accordingly, either by opening up the aperture, using a slower shutter speed, or by using exposure compensation to brighten the image.

Clipping (under- & overexposure)

The histogram also provides great feedback as to whether you've "clipped" the highlight or shadow detail within a shot, i.e. reduced the former to white or the latter to pure black. This is indicated by a thin bar of data at either extreme of the histogram. A bar at the left-hand edge indicates that you've clipped the shadow detail—these areas of the image will be black—while

a bar at the far right indicates that you've overexposed the highlights, which will be rendered as pure white in the final image. However, it's important to note that clipping isn't necessarily a problem, at least not when it's intentional. For example, if you're shooting a high-key portrait in a studio and you want the background to be pure white, the highlights should be clipped. In this case, the overexposure is intentional. On the other hand, if you're shooting a landscape with a brilliant blue sky and a host of fluffy white clouds, clipping the highlights probably indicates that you've overexposed and lost important detail in the clouds. In this case, you would need to use a smaller aperture or faster shutter speed in order to ensure that you retained the detail in this key element within the scene.

Luminosity versus RGB

While virtually all digital cameras provide a luminosity histogram—a histogram that describes the brightness of the pixels within an image—some also give you the option to switch to displaying three histograms: one red, one green, and one blue (this is often referred to as the RGB histogram). The reason for this is because each pixel within your image is comprised of three values—red, green, and blue—that, when combined, determine the overall color of an individual pixel. For most shots, using either the luminosity histogram or the RGB histogram will be sufficient to evaluate an exposure, but on occasion the RGB histogram can be more useful. For example, if you're shooting a portrait and worried about compromising the highlight detail, the Luminosity histogram may indicate that your exposure is correct (i.e. no clipped highlights), but if you switch to the RGB histogram, you could find that while the green and blue channels are OK, the red channel is clipped. In this case, you'll need to underexpose slightly in order to ensure that you capture a full range of tones in the red channel.

↗→ 24mm, ƒ/8, ISO 200 Here, you can see how the histogram follows the exposure. The top scene, shot at 1/1000 second, is quite dark. The highlights are safe, but too much detail is now bunched up in the shadows, and the sky—that blue spike in the middle—is dull and drab. The middle exposure, shot at 1/250 second, goes too far in the other direction. The shadows are open now, sure, but a lot of detail is getting lost in the highlights, and the sky is so bright it's turning white instead of blue. The bottom exposure, shot at 1/500 second, strikes the right balance, preserving most of the tones safely in the mid-tones, allowing the sky to be appropriately bright without going off into pure white.

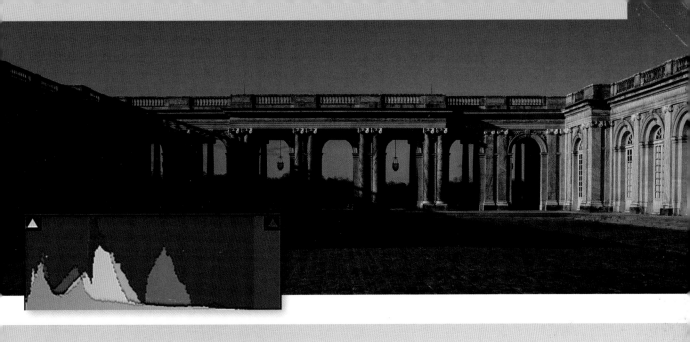

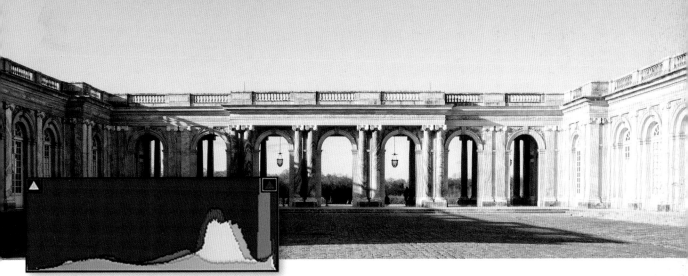

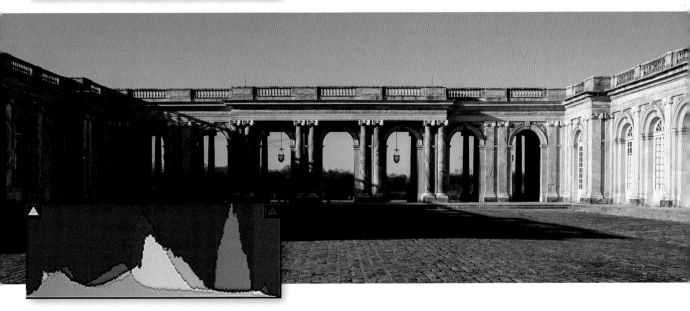

EXPOSURE & METERING

In the previous sections we took a detailed look at how to vary the aperture, shutter speed and ISO to determine a specific exposure, but how do we know which combination of settings will produce the correct exposure for a given scene? For example, a moonlit scene, with a typical EV of around -2, shot at ISO 100 and an aperture of f/5.6 would require a shutter speed of around 8 seconds. Alternatively, shooting during an averagely bright overcast day (around EV 13) using the same aperture and ISO would require a shutter speed of somewhere around 1/100 second to obtain the correct exposure. In short, in order to determine the correct exposure we need to measure the brightness of the scene.

The meter

Fortunately, all modern cameras contain a highly accurate light meter that can measure the brightness of a scene, and most times these in-camera metering systems present us with a reading that allows us to select a combination of aperture, shutter speed and ISO that will correctly expose the scene at hand. On some occasions, though, as I'm sure you've discovered, they seem to get it wrong: the metered image is either too bright or too dark. To understand why this happens we need to take a more detailed look at how these meters work.

All in-camera meters, no matter how sophisticated, suffer from two interrelated problems. The first is that they measure the light reflected from the subject, not the light falling onto it—this is referred to as TTL (through the lens) metering—and the second is that

they are calibrated to work on the assumption that all scenes average out to a medium gray. In other words, they assume that each scene will include a range of tones—from dark to light—and that the average luminance of the scene will fall approximately midway between the two.

So, for example, if you shoot a scene that is unusually bright, one where the reflected amount of light is higher than expected, your camera's meter will produce a reading that will lead to an underexposed image. A typical example in this category would be a winter scene in bright sunlight: if you go with the metered exposure, the scene will be underexposed. By the same token, if you shoot a very dark scene your camera will once again produce an "average" reading, leading to an image that is too bright with respect to the scene at hand. In each case, your camera's meter makes the assumption that the range of tones within the scene will average out to a mid gray. This isn't always the case.

Metering modes

Most modern cameras offer a range of metering options that allow us to circumvent at least some of these problems.

EVALUATIVE/MATRIX:
Nikon's Matrix metering, Canon's Evaluative metering, and comparable systems from other manufacturers don't just rely on the brightness of the scene as a whole, they take a range of different readings from different areas of the scene then compare these

← 24mm, 1/2500 second, f/3.5, ISO 200
The exposure for this scene was easily set using the Evaluative-metering mode. It's a straightforward landscape, in metering terms— bright sky, clear horizon line, somewhat darker fore- and midground with patches of shadow. The meter saw this, compared it against an on-board catalog of thousands of similar shots, and picked an exposure that it had on file and knew would work. If you're shooting straightforward shots like this, it's best to simply switch to Evaluative (or Matrix, or whatever it's called on your camera) and concentrate on composition.

readings to an onboard database of images in an attempt to recognize how the scene should be metered, i.e. rather than simply averaging out the brightness of a scene they attempt to recognize the subject matter and adjust the exposure accordingly. For example, if you're shooting a backlit portrait and basing your exposure on the average for the scene as a whole, more than likely your subject will be underexposed. If you shoot this same scene using Matrix or Evaluative metering, and the system recognizes the scene as such, it will adjust the exposure accordingly: it will increase the exposure to brighten the subject. Often, these "intelligent" systems work well, but they're not infallible.

CENTER-WEIGHTED

Center-weighted metering, rather than metering the scene as a whole, takes a reading from the center portion of the image. For our backlit portrait, then, this would produce a more accurate reading insofar as the subject would be metered while the much brighter background would be disregarded, i.e. the suggested exposure would lead to a brighter image.

SPOT

A final alternative, and one that is becoming increasingly common in both mid-range and high-end cameras, is a spot-metering option. In this case, the metering is restricted to somewhere between one and five degrees of the field of view, allowing you to take a precise reading from a very small area of a scene. This is especially useful if you're shooting a subject that's either much brighter or much darker than the surrounding environment. For example, if you were shooting a street scene at night, with a person looking up towards a light, an average reading for the scene would probably overexpose the person's face. By spot metering this detail, rather than taking an average reading of the scene as a whole, you can set an exposure that correctly records the detail in this small bright area.

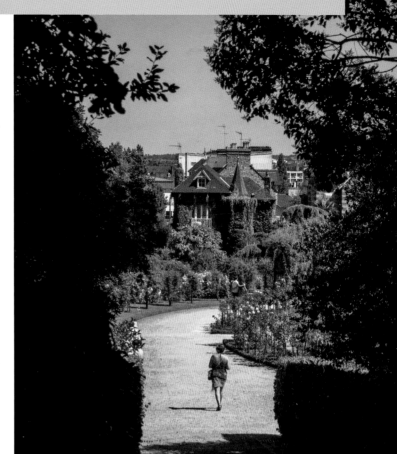

↑ 90mm, 1/500 second, *f*/6, ISO 200
Center-weighted metering mode doesn't typically get a lot of use (it's basically a relic from film days when the only metering that existed was center-weighted), but when you need it, it works perfectly. Here, the exposure needed to balance the bright garden in direct sunlight with the shadow grove framing

the composition. A spot meter would have simply let the grove fall into black, and evaluative would have brightened them up distractingly far, and probably clipped highlights in the center of the frame. So center-weighted saved the day, not ignoring the framing foliage, but giving preference for the scene in the center beyond.

→ 100mm, 1/800 second, *f*/2, ISO 100
This action-packed public pillow fight took place near the end of the day when the sun was quite low and casting brilliant directional light. Amid the crowd, this little girl taking refuge on her father's shoulders stood out, but an evaluative or even

center-weighted show would have hidden her face in shadow, as she was turned with her back to the sun. A quick change to spot meter ensured her face got the priority, and other parts of the scene—including her hair—were allowed to clip to pure white.

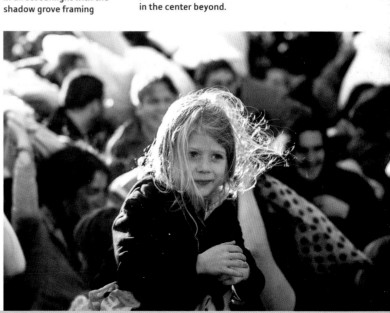

Tricky exposure situations

Often, no matter which metering system you use, your camera will still get things wrong. To illustrate this, try the following experiment. Take a shot of a black or very dark wall, or easier still, photograph a very dark sheet of paper. If you choose the latter option, make sure that you fill the frame with the paper, as you don't want any of the brighter background to influence your camera's meter. Once you've done that, do the same with a while wall or white sheet of paper under exactly the same lighting. In each case, whether you used a form of evaluative, center-weighted, or spot metering, the dark subject will appear too bright and the white subject will be too dark, despite the fact that the light falling onto each subject was identical. In each case, your camera's meter expected the scene to be an average grey and metered accordingly, and in both cases, it produced an image that was "wrong."

One solution to this problem is to meter the scene using an 18% gray card. As its name suggests, this is nothing more than a piece of gray card, but it is designed to reflect the "average" amount of light that your camera's meter is calibrated to. So, if you meter from the card—rather than the scene as a whole—your exposure will more accurately match the level of ambient light. For example, to return to our backlit portrait, if you ask your subject to hold the gray card for an initial exposure and then spot meter the card, the reading will be accurate. By the same token, to photograph our sheets of white and black paper under identical lighting conditions, all we need to do is measure the light reflected from the gray card and then use that measurement to photograph both the black and the white subjects. In each case, the correct exposure is identical for both subjects as both are lit by the same amount of light, which brings us to

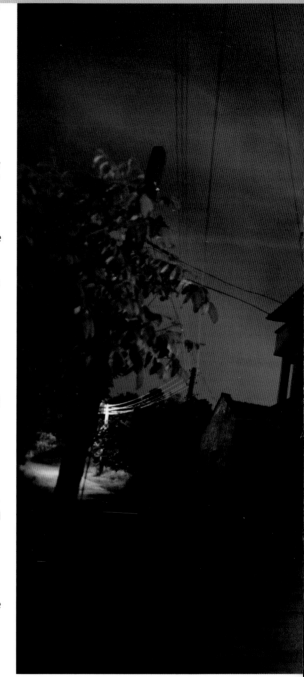

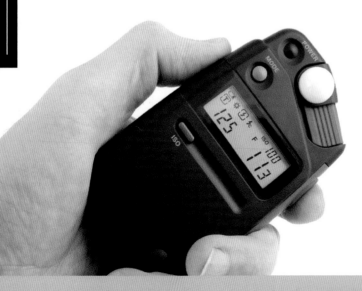

← Handheld lightmeters can be used to measure the light falling on the scene (an "incident" light reading), which can give a more accurate exposure than the reflected reading produced by your in-camera lightmeter.

↑ 16mm, ƒ/2.8, 30 seconds, ISO 100
Metering for a low-light scene such as this is easy with a hand-held light meter as it measures the amount of light falling on the subject as a whole, rather than the amount of light being reflected by the subject. This avoids the risk of deep shadows or bright highlights such as the streetlamp affecting the exposure reading.

the heart of the problem of all TTL metering systems, i.e. they measure the light reflected by an object, not the light falling onto it.

The only way to avoid this problem entirely is to use a handheld meter that can measure the light falling onto a subject—the incident light—rather than the light reflected from the subject. In a controlled environment, where you know the light won't change and you have time to take a reading—shooting in a studio would be a good example—an incident light meter is a great option, but in other circumstances, it simply isn't a viable alternative. For example, if you're a street photographer aiming to capture candid moments as they unfold

across a range of different lighting conditions, using an incident meter simply isn't practical.

Fortunately, once you understand the nature of this problem, solving it becomes relatively straightforward.

As we noted above, when you photograph a scene that reflects a disproportionately large amount of light—a snow scene for example—your camera's meter will underexpose the scene because it expects that the scene will average out to 18% gray when in fact it's reflecting a lot more light than an average scene. Because we know that this is the case, based on our understanding of how our camera's meter views a scene, all we need to do is to deliberately overexpose the image, either by using exposure compensation (if you're shooting in program mode, aperture priority or shutter speed priority), or by lowering the shutter speed or opening up the aperture if you're shooting in manual. The only problem you still need to solve is how much you should adjust the exposure by.

There are two ways you can assess the extent to which you need to change your exposure. The first comes with experience, i.e. with practice you'll develop a good understanding of how a particular scene might "fool" your camera's meter. For example, typically speaking, a snow scene in bright sunlight will be somewhere around two, possibly three, stops brighter than an averagely gray scene. In this case, all you need to do in order to correctly expose the scene is overexpose by two stops. So, if your meter recommends 1/500 second at f/8 at ISO 100, and you're shooting in manual, you know that you will need to change the shutter speed to 1/125 second (two stops brighter) or alter the aperture to f/4 (again, two stops brighter). If you're shooting in aperture priority or shutter speed priority, you need to set your exposure compensation to +2 EV.

The second, related method is to use your camera's LCD preview and histogram. For example, when shooting a snow scene in sunlight you know that the image should be bright, so if the preview images looks overly dark and your histogram is skewed towards the center—most of the tones are recorded as mid grays— you know that you'll need to overexpose to obtain a correct exposure. The additional benefit of using the histogram, in this case at least, is that you'll be able to precisely judge how much overexposure you need, i.e. you want the brightest areas to be almost white, but you don't want to overexpose them and render them as totally white. If you use your histogram to assess this, you can increase the exposure until your data is pushed as far to the right of the histogram as possible without clipping any of the fine-scale detail.

By the same token, I know that if I'm shooting a backlit portrait of my daughter and meter for her face, I'll need to overexpose by around 1 EV as her face reflects approximately one stop (or 1 EV) more light than an

18% gray card. In this instance, though, checking the histogram may not be quite so useful as in metering for my daughter's face, i.e. setting the correct exposure for the key part of the scene may cause the highlight details in the background to be overexposed. In this case, the feedback from the histogram is of less use.

On first reading, the above may sound complex but it's based on the simple idea that your camera's meter works on the assumption that the range of tones in any given scene will average out to 18% gray. If the resultant exposure is "wrong"—either too bright or too dark—it doesn't mean that your camera's meter was inaccurate, merely that the average reflectance of the scene at hand differed from this assumption. In these cases, you need to adjust your exposure to take account of this difference by deliberately overexposing scenes that are brighter than 18% gray and deliberately underexposing those that are darker.

↗↘ 50mm, 1/800 second, f/5.6, ISO 100
Most consumer cameras have, among an ever-growing plethora of specific "Scene modes," dedicated shooting modes for Beach and Snow. That's because these settings are classic cases of overly bright scenes fooling the metering system into underexposing. Don't blame the meter—it's only doing what it's supposed to do, which is take all the readings throughout the frame, equalize them into a neutral 18% gray, and expose for that. But beaches and snowscapes aren't typical scenes—that's why you either squint or wear sunglasses in them! They're much brighter than normal, throughout the frame, and the exposure needs to capture that brightness. Fortunately, it's as simple as dialing up the exposure compensation by one or two stops (which is all those Scene modes are doing anyway).

DYNAMIC RANGE

One of the first things you learn as a photographer is that the way in which you perceive a scene is often quite different to how your camera evaluates and processes the same data. For example, a shot you intend as a backlit portrait may well end up as a silhouette; a shot of a brightly lit scene may end up looking too dark, and so on. In other words, the image you see is sometimes not the one you manage to take. There are two main reasons for this. The first is that your camera will attempt to set an optimum exposure for a particular shot, i.e. it will set the aperture or shutter speed, or both, to ensure that enough light hits the sensor to produce a well-exposed image. When it gets it wrong, as we discussed earlier, we need to change the exposure to produce an image that more closely matches our expectations.

Fitting an exposure on the sensor

The second reason is more problematic. In this instance, the disparity is caused by something over which you have much less control; i.e. the difference between the way in which we see things and how our cameras see them. For example, a shot that you intend as a richly detailed landscape, set against the backdrop of a bright but cloudy sky, may end up with the sky looking as you intended, but the foreground being too dark. Alternatively, the foreground might be correctly exposed, but the sky will contain a range of clipped highlights (i.e. grossly overexposed areas). Or, worst of all, there might be overexposed areas of sky and underexposed areas in the foreground; i.e. areas of black rather than areas of dark shadow. In this instance, adjusting the exposure won't fix the problem, it will just present you with a different problem; e.g. increasing the exposure to compensate for an overly dark foreground will overexpose the sky, while decreasing the exposure to retain the detail in the sky will lead to a very dark foreground.

The problem here is that the dynamic range of the scene you are trying to photograph is larger than what your camera can record. To explain this in more detail, though, we first need to define what is meant by dynamic range. At its simplest, it can be described as the ratio between the lightest and darkest tones within an image and within photography; this is often measured in EV (exposure value) of f-stops. Both of these terms denote the combinations of shutter speed and relative aperture that give the same exposure. An additional term that is often used in this context is "contrast ratio."

To return to our problem—that the scene we see is not always the one that our camera records—when we view a scene, we can perceive an EV range of up to almost 24 EV if we take into account that our eyes can adjust to different levels of brightness. Our cameras, on the other hand, can only record an EV range of between 8 and 14 stops at best, and if you bear in mind that each increase in EV value represents a doubling of brightness, then the difference between even the best we can hope for our camera is significantly less than we can perceive when we view a scene with a large EV range.

In other words, if the scene contains an EV range of around 14 or above then we must reconcile ourselves to the fact that there is no combination of aperture or shutter speed that will allow you to capture the entire dynamic range of the original scene. All you can do in this circumstance is optimize the exposure to capture the shadow detail or the highlight detail, but you will inevitably lose some detail in the process, either in the form of overexposed highlights, underexposed shadows, or both.

From a photographic point of view, there are five solutions to this problem, one of which we'll discuss below, two in subsequent sections, and two in the Special Exposure Techniques chapter toward the end of the book.

First, stop taking shots where you know that the size of the EV range will compromise the quality of the final image, i.e. wait until the light is right, or just shoot something else instead. For example, in the case of a landscape shot, this might mean waiting until dawn or dusk and shooting when the balance of light between the brightest and darkest areas of the scene falls within a smaller EV range.

On the face of it, this doesn't sound much like a solution, but it's based on one of the best pieces of photographic advice I ever received: learn how to see the world as your camera does. Once you can do this, even in a limited way, you'll find that the quality of your images will improve dramatically.

→ 28mm, 1/250 second, f/11, ISO 100
This is an example of a shot that any modern camera sensor should be able to capture with ease. You can particularly see the subtle gradations of tone after it's rendered into a black and white. The sky is still the brightest thing in the frame, but it's cloudy and therefore orders of magnitude less bright than a blue midday sky. The result is that the brightest parts of the sky and the darkest parts of the shadows in the foreground are not too far apart to fit into the sensor's dynamic range.

CONTROLLING DYNAMIC RANGE

In the previous sections to this chapter we investigated three ways in which you can control an exposure, i.e. by altering the aperture, shutter speed, and ISO. In all three cases, we were concerned with controlling the exposure in relation to the naturally occurring ambient light. In some cases, though, this can cause problems, especially when the light levels are low, or when the light is distributed unevenly within a scene. Let's take a look at each of these problems in turn.

Based on our previous discussions, we have four ways in which we can deal with a scene that is poorly illuminated: we can shoot using a wide aperture, a long shutter speed, a higher ISO, or any combination of the three. In some circumstances though, even though we can employ these methods to allow enough light to reach our camera's sensor, we might not be able to capture the shot we desire. For example, if you are attempting to shoot an indoor scene with an EV of around 6 at an aperture of f/5.6 (to capture a sufficient depth of field), then the metered shutter speed would be around half a second. If you also want to freeze the movement within this scene—i.e. people moving around within the frame—you will need to use a shutter speed of at least 1/60 second. In order to do this, you would need to increase the ISO to 3200 (i.e. an increase equivalent to raising the light levels by 5 EV). To do so though, with most cameras at least, would add a noticeable amount of noise to the final image.

Add your own light

In these circumstances, the only viable alternative is to add light to the entire scene; i.e. use one or more flash units to add to the ambient light, raising it to the point whereby your can shoot using the desired aperture and shutter speed without compromising the final image by raising the ISO to an unacceptably high level. In other words, the flash replaces the ambient light as the main source of illumination.

FILL LIGHT

In other circumstances, we can face a different problem; i.e. the ambient light might be quite bright overall, but it can be unevenly distributed within the frame. In these circumstances, exposing for the brighter areas of the scene will cause other important areas to be too dark. This is often the case when shooting portraits in bright sunlight; i.e. the angle of the sun can be such that areas of the subject's face or body can be in heavy shadow. In these circumstances, we need to selectively add light to the scene, i.e. use flash to "fill" the shadows, thereby producing a more balanced image. By the same token, fill-flash can also be used more creatively; i.e. to draw attention to a particular area of a scene. For example, it can be used to lighten the foreground when used on-camera, or any other area of a scene when triggered remotely.

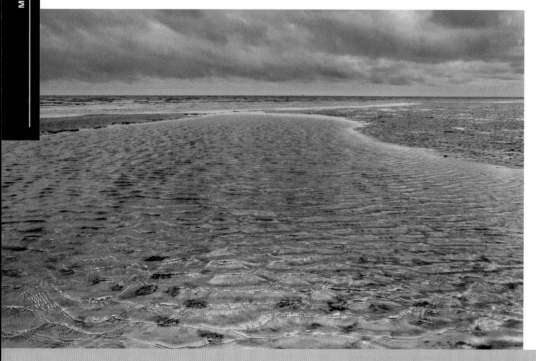

← 17mm, 1/30 second, f/5.6, ISO 100
Most people don't think of flash as a tool for landscape photography, but here a subtle burst of fill-flash helps add a sparkle to the ripples in the foreground.

↗ 50mm lens, 1/250 second, f/8, ISO 100
As well as providing a subtle touch of fill-in lighting, flash can also be used to overpower the ambient light, making it the dominant source of illumination.

It is common sense that light gradually decreases in intensity (or "falls off") as it travels greater distances. If you're going to be adding your own light to a scene, it is essential that you be able to precisely predict that degree of fall-off to make sure your subjects are adequately lit. Toward that end, flash photogrpahers work according to the inverse square law, which states that the intensity of light falling on a subject is inversely proportional to the square of the disance from that subject. While that may sound like a mouthful, in reality it's quite straightforward. For example, if you have two subjects of equal size, one of which is twice as far from a light source as the other, the more distant subject will receive only 1/4th as much light as the closer subject. In lighting terms: doubling the distance cuts the light down by two f-stops. The most noticeable thing about this comparison chart of the main light sources used in photogrpahy is that the sun's light does not seem to change with distance. This is because the distance between the earth and the sun is so much greater than any local differences.

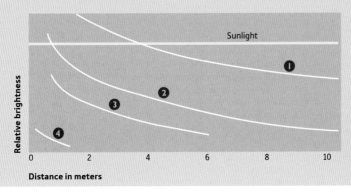

1 800-joule studio flash (guide number 210)

2 on-camera flash (guide number 40)

3 800-watt tungsten halogen lamp

4 60-watt tungsten halogen lamp

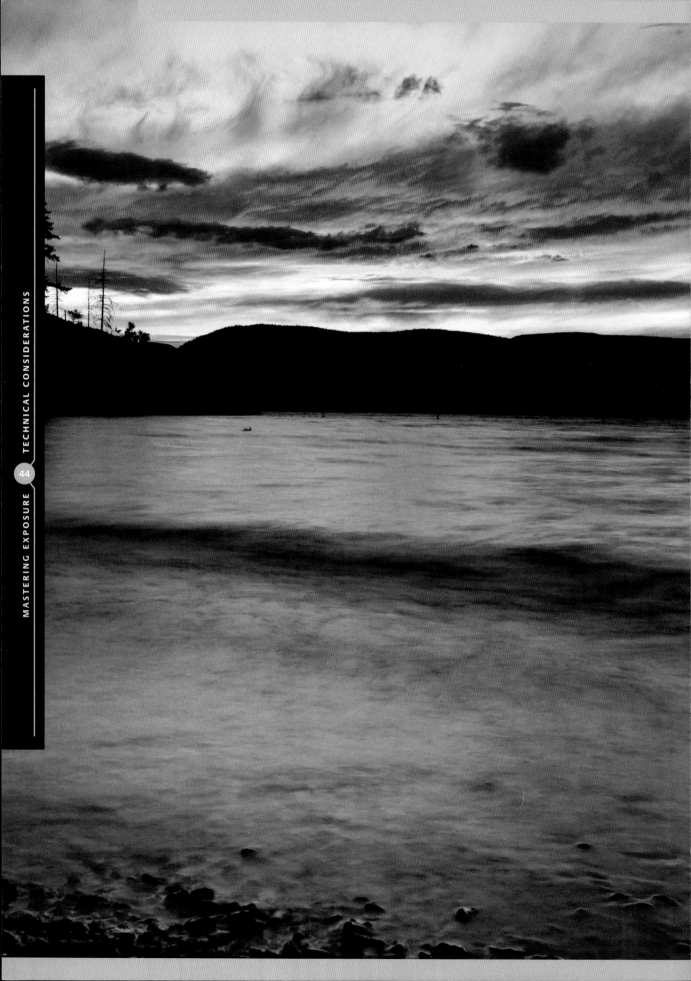

In the previous section, we discussed how our perception of the world differs from our camera's, using the example of a richly detailed landscape offset against a very bright but cloudy sky. To us, this is a scene full of interest and drama, but our camera can't render both areas of the scene simultaneously, i.e. if we expose for the sky, the ground will be too dark. Vice versa and we risk overexposing the highlights in the sky. One solution to this problem is to use a graduated neutral density filter (ND Grad).

Graduated neutral-density filters

An ND Grad has a clear area, a dark area, and an area of transition between the two. Lee filters, for example, provide a range of ND Grads from one stop to four stops, in half-stop increments, with a choice of either a hard or soft transition. A soft transition is useful when you want the effect to be gradual, whereas a hard transition is more useful if you have a clearly defined and straight horizon, such as with a seascape.

The main use of an ND Grad is to correct the problem we identified above, i.e. adjust the tonal balance of an image by darkening the brighter area to match the darker area, in this case, darkening down the sky such that its tonal range more closely matches the ground. The easiest way to use one is to meter the ground and sky separately. You don't need to be 100% accurate in doing this, so just point your camera at the ground, maybe placing the horizon just above the top of the frame, and note down the meter reading. Once you've done this, do the same for the sky. All you then need to do is calculate the difference between the two exposures and choose an appropriate ND Grad.

For example, if the ground meters 1/50 second at $f/8$ and the sky meters 1/200 second at the same aperture you would need to use a 2-stop ND Grad in order to compensate. If the difference exceeds four stops, you can stack multiple ND Grads accordingly, so if there was a five-stop difference you could use a 3-stop and a 2-stop ND Grad at the same time.

ND Grads aren't without their problems, though. First, they can be quite expensive—a single ND Grad from Lee filters is around $75. Second, while the filter itself is reasonably small, you will also need an adapter for your lens, an attachment ring to hold the filter, and a dedicated hood if you're worried about flare; i.e. it's a lot more stuff to carry around.

More importantly, they are of little or no use when a key element of your shot bisects the horizon, as the upper section would be unnaturally dark in comparison to the lower section. In this sense, they are only really useful for landscape photography, and then only when there are no significant elements that cross the horizon.

45

← 24mm, 1/50 second, $f/11$, ISO 100
This shot could have been taken only with an ND Grad filter (assuming no Photoshop composites). The sun is already behind the mountains in the distance, casting the fore- and midground into shadow. The grad filter held the sky's brightness back just long enough for the darker and lower part of the frame to shine through, equalizing the exposure.

→ Graduated neutral density filters don't usually fit directly into the lens filter threads like most filters; instead, they fit into this accessory holder. The holder screws into the lens and then the filter slides into the vertical slots on either side of the holder. You are free to slide the filter as far up or down as you see fit, in order to line up the gradation with the horizon line without having to readjust your camera or compostion.

ETTR: EXPOSE TO THE RIGHT

Most books on exposure aim to equip you with the skills you need in order to nail your exposure in-camera and the preceding sections were no exception: each was written on the assumption that we should be aiming to get as close as possible to the image we envisage as we take the shot. As you'll see in what follows, this may not be the best advice.

Bit depth

To explain why, we need to take a more detailed look at the way in which your camera records data. Most current DSLRs or equivalent cameras are capable of creating a 14-bit Raw file. This means that every pixel within your image can be stored at one of 16,384 levels of brightness (two to the power of 14). So why is this significant?

Stops	Levels
1st stop	8192 levels
2nd stop	4096 levels
3rd stop	2048 levels
4th stop	1024 levels
5th stop	512 levels
6th stop	256 levels
7th stop	128 levels
8th stop	64 levels

In other words, if you underexpose by just one stop you sacrifice 50% of the data you could have captured, two stops and you throw away 75%, three stops 87%, and so on.

Minimizing noise

By far and away the biggest source of noise in an image is shot noise, something we can do absolutely nothing about—it's a pervasive feature of light. We also discussed how shot noise is much more of a problem in low light than it is in bright light because the noise-to-light ratio is much higher. In other words, there will always be more noise in the darker areas of an image than there will in the brighter areas.

One way to avoid this is to "expose to the right," i.e. shift the exposure as close to the right-hand edge of the histogram as possible without clipping the highlights. This will create an image that contains a full range of tones, but it will appear too bright. To counteract this, the image can be darkened during the Raw conversion process. But why go to all this trouble?

Imagine a scene with a dynamic range of six stops, and then imagine that scene inadvertently or intentionally underexposed by two stops. Your camera has a dynamic range of eight stops, so you would have recorded all the data, but in skewing it towards the left of the histogram, you threw away 75% of the data you could have captured.

As we discussed earlier, every image contains noise, but the extent to which this is problematic depends, in part at least, on the noise-to-light ratio. Put another way, the level of noise remains constant, irrespective of brightness, but the brighter the light, the less visible it will be as the signal-to-noise ratio is better. For example, in the first stop where we have 8192 levels of brightness, the noise is effectively invisible. In the lower stops, where we have much less data, the noise will be considerably more noticeable, or may overpower the signal altogether.

To return to our example, because the dynamic range of the scene was six stops, and we underexposed by two, the deepest shadows fall into the 8th stop, where we only have 64 levels of brightness to describe the tonality of the scene. Chances are the noise will be very evident, especially if we try to brighten this area as the signal-to-noise ratio is low.

Alternatively, had we exposed to the right, this shadow detail would have fallen into the 6th stop, where we have 256 levels to describe the tonal range. In this case, our signal is four times stronger (64 x 4 = 256) so the signal-to-noise ratio is much better.

In summary, exposing to the right and then darkening an image during the Raw conversion process will always produce an image with less noise, but the extent to which this is either necessary or, indeed, worth the effort will depend on whether a) the detail in the very darkest areas of the image is intrinsically significant, and b) you intend to brighten these areas in post. If so, particularly if you intend to brighten these areas significantly, exposing to the right as you take the shot will give you more and cleaner data to work with.

→ 90mm, 1/100 second, ƒ/5.6, ISO 320
This shot was created with every intention of being low key, with an emphasis throughout the frame on the shadow, in order to highten the drama of the sunlight streaming diagonally across the frame. One might think it was intentionally shot underexposed—particularly as the dynamic range between the shadows and the bright stained-glass windows is already pushing the extremes of the sensor's capabilities. And in fact, it was shot quite a bit brighter than this—right up to the point where the windows were about to clip to pure white. In post-production, the exposure was then pulled down to the point where you see it now. As a result, the entire image—particularly the shadows—are exquisitely black and noise-free. And there's still more than enough detail and color fidelity in the highlights.

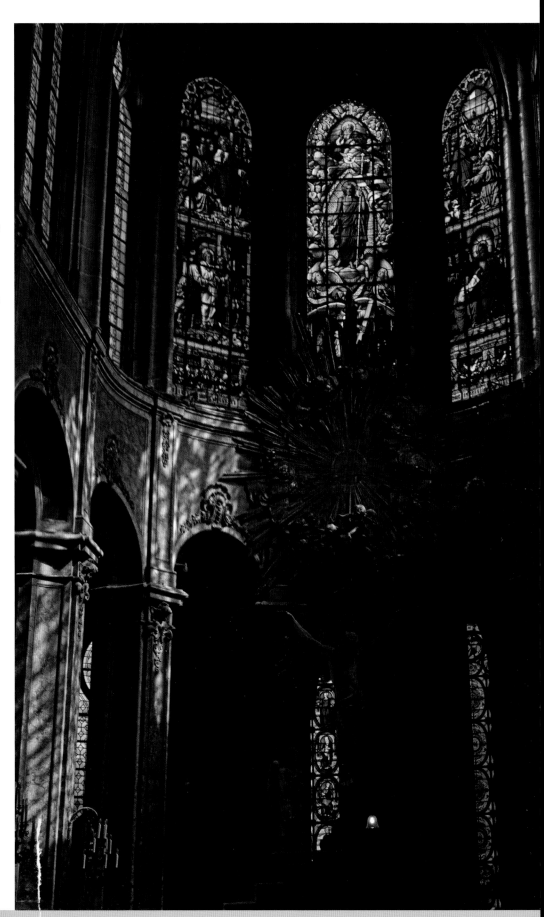

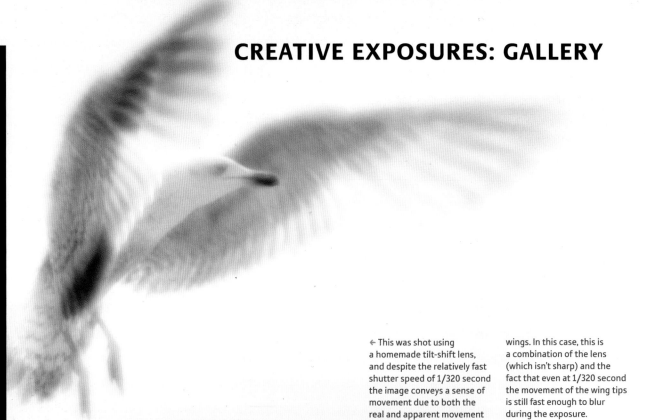

CREATIVE EXPOSURES: GALLERY

← This was shot using a homemade tilt-shift lens, and despite the relatively fast shutter speed of 1/320 second the image conveys a sense of movement due to both the real and apparent movement of the bird, particularly its wings. In this case, this is a combination of the lens (which isn't sharp) and the fact that even at 1/320 second the movement of the wing tips is still fast enough to blur during the exposure.

→ This is a composite image, hand blended from three exposures, all of which were shot at f/5.6 at ISO 100. The three exposures were 2/3 stops apart—1/8 second, 1/13 second, and 1/25 second—and were blended to ensure a full range of tones in both the brightest and darkest areas of the original scene.

→ This was taken at a set of traffic lights in Dubai at ISO 100, f/2.8 with a shutter speed of 1/3 second. Despite the relatively fast shutter speed, the lights are extremely distorted as the camera was deliberately rotated during the exposure. The dotted trails are fluorescent light sources.

← This is a stitched composite of six exposures, all of which were shot at f/5.6 (the sharpest aperture of my 16–35mm f/2.8 lens), ISO 100, and 8 seconds. In this case, the shutter speed is the most important of these settings: just long enough to create smooth trails of the car's lights along Sheikh Zayed Road in Dubai.

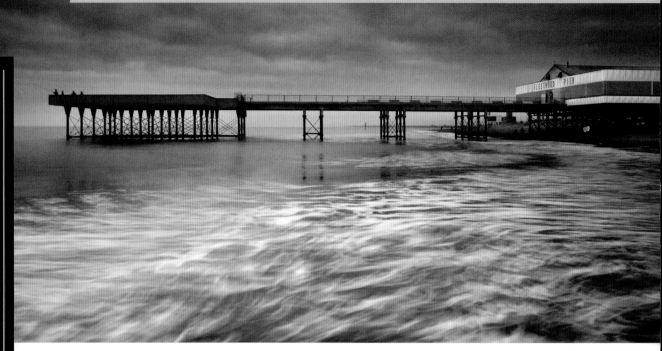

↑ This shot of Fleetwood Pier on the northwest coast of the UK was shot at ƒ/16, ISO 100 with a shutter speed of 1.3 seconds—just long enough to blur the incoming waves, creating a sense of motion that complements the static components.

↓ This was shot at ƒ/5.6, ISO 100 and a shutter speed of 1/800 second, two stops underexposed from the metered exposure. To add richness and saturation to the sky, control the overexposure of the sun in the frame and render a silhouette.

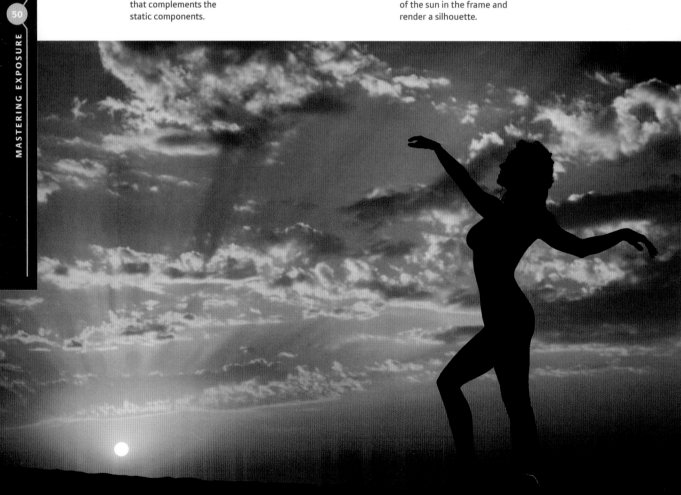

↑ As light passes through the aperture of a lens, it diffracts or spreads out around the blades of the aperture to create a starburst effect as illustrated by this image which was shot at f/16 (120 seconds at ISO 100). At wide apertures, this effect isn't especially noticeable, in fact any point light sources in an image will look more like an ill-defined blob than a star, but by f/11 and smaller the starburst will be very clearly defined.

↓ As a general rule of thumb, if you want the stars in a night scene to be sharp you need to shoot with a shutter speed calculated by dividing the focal length of the lens you're using by 500. In this instance, I was shooting at 32mm so the longest shutter speed I could use was 15 seconds (at f/2.8 and ISO 3200). At any shutter speed longer than 15 seconds, the rotation of the earth during the exposure would cause the stars to appear as trails rather than point sources of light.

ADDITIONAL NOTES FOR FILM USERS

While virtually all of the techniques we will discuss later in this book can be carried out using either a digital or film-based camera, there are three things that you will need to bear in mind if you are shooting film.

ISO

Film-based cameras are less flexible than their digital counterparts in that you need to choose a film with a particular speed, rather than being able to vary the ISO on an image-by-image basis. However, shooting with a high-ISO film will often produce esthetically better results than high-ISO digital capture, simply because the grainy nature of film is more appealing than digital noise, appearing "organic" rather than "artificial."

Film & dynamic range

As mentioned previously, the dynamic range of most digital SLRs falls somewhere between 5 EV and 9 EV, but with film, the dynamic range is determined by the type of film you use. Slide film, for example, shares a similar dynamic range to a typical digital sensor, but color negative (print) film is able to record an EV range of up to around 12 EV. Black-and-white negative film can have an even higher dynamic range. So, when you are shooting scenes with a high dynamic range, you have a greater chance of capturing the entire contrast range in a single shot when using a film-based camera and negative film.

Reciprocity failure

While the above points are interesting, their impact on most of the topics we will be covering in subsequent chapters is minimal. Reciprocity failure, on the other hand, is something you do need to understand in more detail, especially when it comes to shooting ultra-long exposures.

A digital sensor generates a signal that is proportional to the amount of light it receives, so if the amount of light increases, the signal increases by a relative amount, regardless of the exposure time. Under normal levels of illumination, film responds in the same way, but when the scene demands a significantly longer exposure, this proportional relationship begins to break down.

The reason for this is that the light-sensitive grains in a film require a discrete number of photons to strike them before they become developable. Under normal circumstances (at relatively short exposures), sufficient photons will hit the grains in a reasonably short period

of time, causing the photochemical reaction to take place. However, with long exposure times, the rate at which the photons strike the grains is too slow to produce the photochemical change. This means film effectively becomes increasingly insensitive as the light levels fall, so you need to use an even longer shutter speed than you might predict. Fortunately, most film manufacturers include a data sheet indicating how to correct your exposures to take this issue into, but if you are in any doubt, I would recommend that you shoot a range of additional (longer) exposures to make sure you get the shot you want.

Metered Shutter Speed	Velvia 50 Shutter Speed
4 seconds	5 seconds
8 seconds	12 seconds
10 seconds	16 seconds
12 seconds	19 seconds
16 seconds	28 seconds
20 seconds	39 seconds
25 seconds	49 seconds
32 seconds	66 seconds
40 seconds	88 seconds
50 seconds	116 seconds
64 seconds	158 seconds

⬆ In this reciprocity chart for Fuji Velvia 50 film, you can see how dramatic the difference becomes between the metered shutter speed and the actual shutter speed, eventually requiring over twice as long an exposure as the the meter suggests. There's no way for you to figure this information out for yourself (well, unless you want to burn through a lot of film doing trial and error), it's simply a characteristic of that particular type of film, and charts like these are typically included in the package for reference.

↑ 35mm, 3.2 seconds, f/8,
Fuji Velvia 100
As exposure times increase
in low-light situations, film
effectively becomes less
sensitive to the light, which
requires the exposure to
be extended even further.

CHAPTER 2

SHUTTER SPEED

"To speak technically, photography is the art of writing with light. But if I want to think about it more philosophically, I can say that photography is the art of writing with time. When you capture an image, you capture not only a piece of space, you also capture a piece of time. So you have this piece of specific time in your square or rectangle. In that sense, I find that photography has more to do with time than with light."
—Gerardo Suter

Of all the controls that can be varied to shape and alter an exposure, shutter speed provides the greatest latitude. From freezing the motion of events that are far too fast to perceive, to capturing the rotation of the earth beneath our feet, altering the shutter speed of our exposures allows us to explore the world in a way that transcends our everyday vision in often unique and compelling ways.

In this section, we'll explore this in more detail, in terms of duration (short exposures versus long exposures), movement (subject speed, motion blur, and moving the camera in relation to the subject), and with reference to a range of examples chosen to illustrate the broad range of creative possibilities that are available to you.

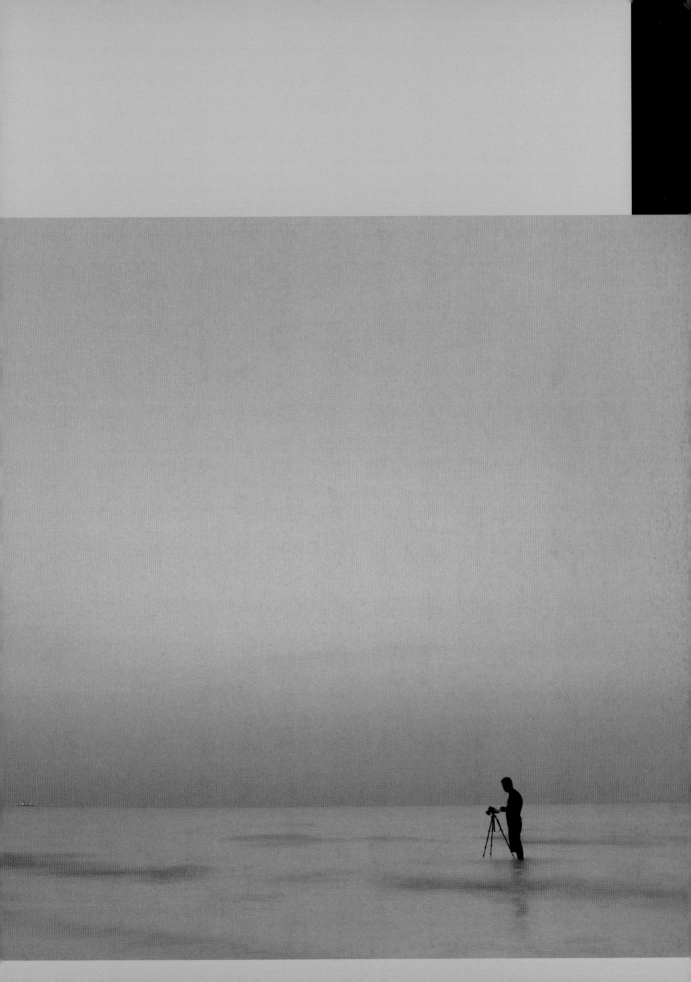

MATCHING SHUTTER SPEED TO SUBJECT

Of the three settings that control your exposure, the shutter speed gives you the most leeway as it covers a greater EV range than the aperture or ISO. For example, a shutter speed range of 30 seconds to 1/8000 second—typical of most DSLRs—offers you 18 stops of control. By comparison, even a very fast lens with a maximum aperture of f/1.4 and a minimum of f/22 only covers eight stops, while a camera capable of shooting from ISO 100 to 51,200 can only vary the exposure by nine EV. More importantly, as I mentioned in a previous section, controlling the shutter speed allows you to create a range of images that go well beyond our abilities of human vision: freezing instances of time that occur far too rapidly for us to perceive, through to stretching motion across time to create abstract interpretations of a scene.

Freezing subject movement

The extent to which an object within a shot will appear stationary depends on both the speed with which it is moving in relation to your camera and its distance.

Object speed

While many photographs give the impression that the movement within a frame was frozen by a particular exposure, this is never the case; i.e. every exposure takes a finite amount of time, and every moving object within a scene will move during that exposure. The faster the shutter speed though, the less perceptible this motion will be. For example, if you were photographing a giant turtle ambling through your frame, a relatively slow shutter speed of around 1/25 second would be more than fast enough to freeze the action. If the object is moving faster then the shutter speed needs to be proportionally shorter. For example, to capture the detail in a breaking wave requires a shutter speed of at least 1/500 second, if not higher.

At this stage, it's also worth noting that the speed at which an object is moving needs to be considered in terms of its speed in relation to your camera. If your camera isn't moving, then the speed is a fixed variable, but if your camera is moving in relation to the object—

← 60mm, 1/60 second, ƒ/8, ISO 100
A still life gives you all the time in the world, so clamp the camera down on a tripod and let the shutter speed drop in order to get optimal settings for aperture (usually in the middle range, but that depends on the lens) and ISO (either 100 or 200, or simply whichever is your camera's base ISO).

↑ 200mm, 1/1000 second, ƒ/2.8, ISO 3200
Sports, on the other hand, give you very little room to maneuver your exposure. It's often best to operate solely in Shutter Priority mode, because that's what is going to make or break your shot. Wide-aperture telephoto lenses are essential, and high ISOs are a natural consequence of sticking to high shutter speeds in lower lighting conditions.

a technique referred to as "panning"—then the relative speed of the object will be a lot lower; i.e. its motion can be frozen using a slower shutter speed while the background will become blurred.

Object distance

While the speed an object is moving has a huge impact on the shutter speed you need to freeze it, its distance from the camera is also important. For example, the average walking pace is around 1m per second. If the person is close to the camera, they will traverse the frame in a second or two. As such, you would need a reasonably fast shutter speed of around 1/250 second to freeze their movement. If they are farther away, say 100m from the camera, the relative distance they travel through the frame is shorter, i.e. a shutter speed of around 1/25 second or 1/50 second would be sufficient to apparently arrest their motion.

Enhancing subject movement

While a high shutter speed can freeze movement that is often too fast to perceive, a longer shutter speed can add movement and blur that is equally imperceptible to the human eye. For example, a shutter of 1/4 second can add motion to a seascape while a longer shutter speed of around 30 seconds, can smooth out the waves to the point where they look more like mist than water, convert car lights on a highway to ribbons of light, or blur people in an urban scene until they are barely visible.

Again, the shutter speed you need to use to add blur and motion depends on two factors: the speed with which the subject is moving (slower moving subjects will require a longer shutter speed to add blur), as well as the distance between the camera and the subject. For example, if you're shooting a night sky with a wide-angle lens, a shutter speed of around 30 seconds will just about freeze the motion of the stars. They're a long way away, and as such their motion appears to be slow. Once you extend beyond 30 seconds—when you measure your exposure in minutes or hours rather than seconds—the stars will appear to move, creating circles that ring the North Star. The longer the exposure, the longer the trail of light they create.

Adding a sense of motion to static scenes

So far we've discussed how to freeze or enhance the motion within a scene, but it's also possible to create a sense of motion within static scenes, i.e. ones where none of the elements are moving. To do this you can either move the camera or zoom the lens during the exposure, i.e. while the shutter is open. In both cases, the extent of the change you make during the exposure determines the amount of apparent movement: large movements of the camera add more movement, as does zooming through a wider range.

← 135mm, 1/2 second, ƒ/5.6, ISO 200

This sunset scene was getting very dark, and ƒ/5.6 was the widest aperture possible at the telephoto end of the zoom. But at times like these, rather than packing up and going home, consider dropping your shutter speed into the danger zone and seeing what kind of shots result. This one was carefully panned following a bird in flight to create a generally abstract shot that nonetheless communicates the idea of flight quite well.

↓ 18–36mm zoom, 1/2 second, ƒ/10, ISO 200

This kind of zoom-burst effect is well suited to colorful, dense subjects, like this forest in autumn. It also takes some practice to keep the camera relatively stable while racking the zoom, but the results can be well worth it.

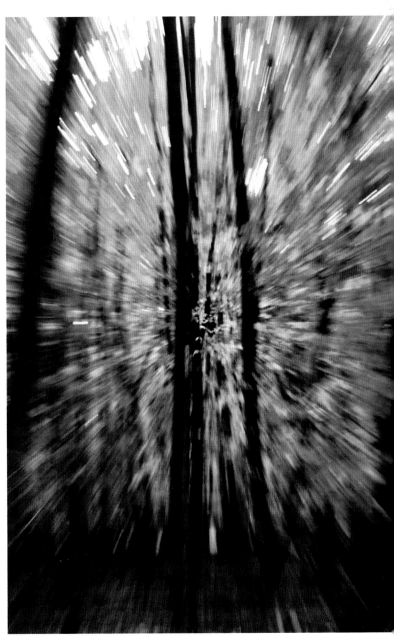

A note about camera shake

In the previous examples, I assumed that your camera is either stationary or that any movement was intentional. What you should bear in mind, especially when using slower shutter speeds, is that unless your camera is mounted on a tripod or supported using some other method, the physical act of holding your camera will introduce some movement. As a general rule of thumb, any exposure that is longer than the reciprocal of the focal length of the lens you are using will probably be blurred as a result of the movement of your camera during the exposure. In plain language, if you are using a 24mm lens, you need to use a shutter speed of at least 1/25 second, while a 50mm lens requires a shutter speed of 1/50 second and a 200mm lens requires one of 1/200 second. If you have steady hands, you may get away with using slightly slower shutter speeds, but if your hands are less steady you might need to use shorter speeds.

NATURAL LIGHT, SHORT EXPOSURES

Ultra-short shutter speeds are essential if you want to freeze motion, allowing you to record a fleeting moment in time—even those imperceptible to the eye—with all its detail. However, minimizing the amount of time that the shutter remains open restricts the amount of light that is recorded, so there are three things you need to bear in mind: the brightness of the scene you are photographing, the maximum aperture you can use, and how far you are willing to increase the ISO.

As you will remember from chapter one, the brightness of a scene can be expressed in EV, and each exposure value determines the combinations of aperture and shutter speed you can use to create an optimum exposure. For example, a typical scene in full sunlight has an EV of 15. When shooting at f/2.8 at ISO 100, you would need a shutter speed of 1/4000 second to get the correct exposure, but shooting the same scene on a heavily overcast day (EV 12) would mean using a shutter speed of 1/500 second to maintain the same aperture and ISO settings. This might suggest that shooting when the sun is at its brightest is the best answer when you want to use the fastest possible shutter speed, but from an aesthetic point of view this might not be ideal. Strong directional sunlight might provide the quantity of light you need, but it doesn't always provide the right *quality* of light. Direct sunlight is always very harsh, which causes a range of technical problems, such as very dense shadows, or a high dynamic range that means you have to sacrifice highlight detail, shadow detail, or both.

A second issue that arises if you want to use a fast, action-freezing shutter speed is that you will almost certainly need to use a wide aperture. This is fine if you're happy with a shallow depth of field, but it's no help if you want more of the image to appear sharp. The answer, of course, is to increase the ISO so you can use a fast shutter speed *and* a small aperture, but you'll immediately be increasing noise, and this can start to degrade the image.

Ultimately, what this all means is that using ultra-short shutter speeds can involve some degree of compromise, whether it's the aperture and depth of field, or the ISO and noise. Don't let this put you off, though—there might be compromises involved, but ultra-short shutter speeds are still capable of producing images that can record split-seconds of time that are either invisible to the human eye, or pass too quickly to be truly appreciated.

↗ 38mm, 1/2000 second, f/8, ISO 100
This striking image required an ultra-short shutter speed to not only freeze the action of the silhouetted soccer player, but also to prevent the sky—with the sun in the frame—from appearing heavily overexposed.

→ 40mm, 1/800 second, f/7.1, ISO 100
An ultra-short shutter speed is the only answer if you want to guarantee sharp pictures of fast-moving subjects. Timing is equally important for positioning the subject.

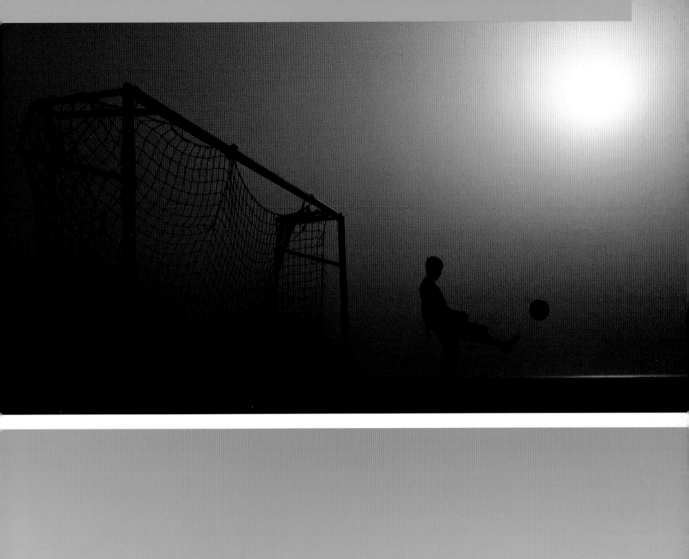

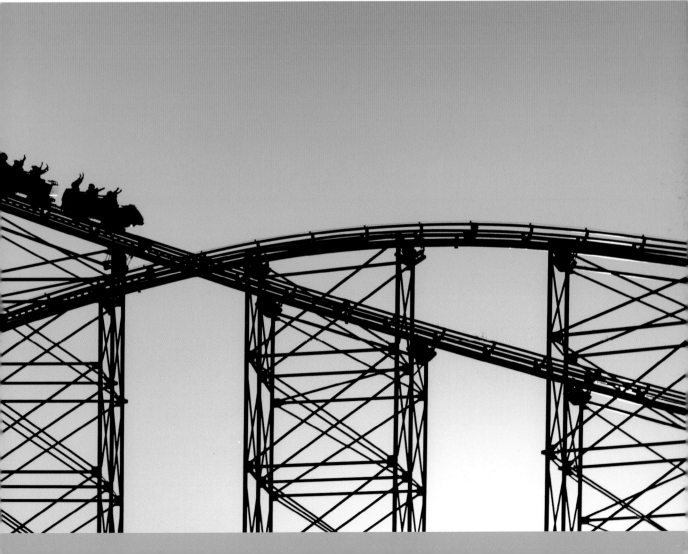

SUBJECT MOVING, CAMERA FIXED

It goes without saying that the faster a subject is moving, the faster is the shutter speed required to freeze the movement, but the speed of your subject is not the only issue. For a start, subject distance plays a part. Moving subjects that are close to the camera will appear to move more than those farther away, so a closer subject requires a faster shutter speed. The direction of the movement is also significant—subjects moving across the frame will appear to move more than those heading directly toward or away from the camera, so again, lateral movement means a faster shutter speed.

With a digital camera, it's usually easy to establish the correct shutter speed for a shot—you simply make a test exposure and check the image on the camera's screen. If the shot is blurred, you can adjust your shutter speed accordingly, and shoot again. This is great, but it only works if you have the opportunity to retake the shot and by its very nature, a moving subject is unlikely to be in the same place when you come to shoot again. If you

are in any doubt over the "correct" shutter speed to freeze movement then the simple rule is to use the fastest shutter speed you can—the faster the shutter speed, the sharper the image.

To maximize the control you have, it's best to switch your camera to Shutter Priority mode. This will let you to set the shutter speed you want, and in ideal conditions your camera will choose an appropriate aperture. However, when the light levels are low, choosing a fast shutter speed can lead to underexposure. For example, if you were shooting on an overcast day (EV 12), a shutter speed of 1/1000 second would require you to shoot at $f/2$ (at ISO 100). But if your lens has a maximum aperture of $f/4$ this means the image will be underexposed by 2 EV. This gives you three options: lower the shutter speed to 1/250 second and risk slight blurring; increase the ISO by two stops and introduce more noise, or adjust both by one stop. Either way, it's a question of compromise.

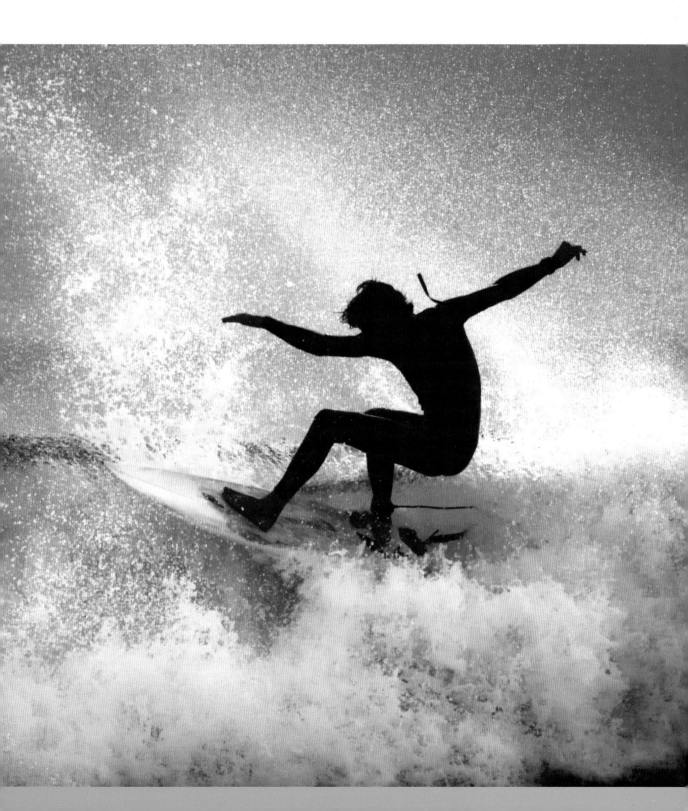

↙ 17mm, 1/500 second, *f*/8, ISO 100
While the speed of your subject has a huge impact on the shutter speed, the subject's distance from the camera, and the direction of its movement are also important. The girl in this shot is close to the camera and moving across the frame, and despite not moving very fast, a fast shutter speed of 1/500 second still reveals motion blur in her feet.

↓ 200mm, 1/1000 second, *f*/5.6, ISO 200
The combination of bright backlighting and fast-paced action demands an ultra-short shutter speed to freeze the moment. A fast shutter speed also lets you handhold the camera with longer lenses, without the risk of introducing camera shake.

LOW-LIGHT PHOTOGRAPHY

Dimly lit scenes, such as landscapes at twilight or just before dawn, a candle-lit room, the lights of a city at night, and so on, are inherently photogenic. As we will see in this chapter, low-light photography covers myriad subjects, from moonlit landscapes, to light trails in a bustling city. Each one can produce images with a uniquely beautiful character, but they all have one thing in common—the use of a long exposure.

A long shutter speed will let you record low-light scenes without using flash—a useful tool in some situations, but one that can easily ruin the atmosphere of low-light photographs. This means the most important tool you need is a tripod or similar support. Even if you have extremely steady hands, and an image-stabilized lens (or your camera has sensor-based stabilization), your camera will move slightly during *any* handheld exposure. With short shutter speeds this movement is negligible and doesn't appear to affect the image, but as the length of the exposure increases, any minor movement begins to affect the final picture. So, when you're shooting extended exposures, a tripod or some other means of support is absolutely essential if you want sharp images.

If you don't have a tripod—or don't have one with you—brace your camera against a solid object such as a wall, the ground, a fence, or similar. Providing your camera is properly supported, you can shoot your low-light images at a low ISO setting to keep images free from noise, and you can use a small aperture to maximize the depth of field—useful for sweeping low-light cityscapes and landscapes.

While it may sound counterintuitive, the shorter your extended exposure is, the more important it is to use a remote release, as well as a tripod, rather than manually activating the shutter. The reason for this is that when you press the shutter—even with your camera supported on a sturdy tripod—you run the risk of introducing vibrations simply because you are touching it. With very long exposures, the minor vibration at the start of the exposure is unlikely to compromise the final image because your camera will remain stationary for the majority of the exposure—the movement makes up only a small part of the overall exposure. However, with shorter exposures (but not *short* exposures) the movement affects a proportionally longer part of the overall exposure, so any minor vibrations can compromise the sharpness of your images. To counter this, use a cable release, remote electronic release, or, as a zero-cost alternative, your camera's self-timer. Set the timer to its maximum countdown (usually 10 or 12 seconds) and press the shutter release to start the timer. When the camera fires, your hands won't be touching it, which will reduce the risk of photographer-induced vibrations. If your camera has one, activate the mirror lock-up facility to reduce any potential vibrations even further.

← 1/8 second, ƒ/2.0, ISO 50
Shooting in low-light situations usually means using slow shutter speeds that can introduce movement into your photographs. Using a tripod and a remote release (or your camera's self-timer) can help.

→ 16mm, 0.4 second, ƒ/6.3, ISO 100
Using a low ISO sensitivity will extend the exposure time required for your low-light shots, but it will also produce images that exhibit less noise than a higher ISO setting.

Setting the shutter speed

Although using a long shutter speed is the key to low-light photography, the actual duration of the exposure is unimportant in most situations. For example, if you are photographing a landscape just after sunset, a low ISO sensitivity to minimize noise and a small aperture to give you the maximum depth of field are the best starting point. If you use Aperture Priority, the camera will set the shutter speed and—assuming you're using a tripod—it doesn't much matter if the shutter speed is 1/4 second, five seconds, or even 30 seconds because it is a relatively noise-free exposure and the depth of field that matter most.

However, on other occasions, the precise duration of the exposure may be more important, especially when there's movement in the frame. For example, if you are photographing a waterfall in twilight you might want to restrict the shutter speed to a few seconds to add a suggestion of motion blur. Alternatively, you might prefer to use your camera's longest shutter speed setting to turn the water into a misty veil. In either case, setting your camera to Shutter Priority—to control the shutter speed—and setting a low ISO to minimize noise would be the ideal starting point, with the camera determining the aperture.

With most cameras, the longest exposure time you can set in Shutter Priority mode, and the longest indicated exposure your camera will provide when shooting in Aperture Priority or Manual, is 30 seconds. This is usually long enough for most low-light situations, but as we will see, there are some low-light situations that work best if you use exposures measured in minutes, or even hours, rather than seconds. For these projects, you will have to switch your camera to its Bulb mode, which will let you manually hold open the camera's shutter to make the exposure. This might mean you have to depress and hold the shutter button for the entire duration of the exposure, or you have to trigger the shutter to start the exposure and trigger it a second time to end it.

→ 17mm, 30 seconds, ƒ/5.0, ISO 100
To avoid camera shake ruining your long-exposure photographs, your camera needs to be supported. A tripod is the most common solution, but you can also use a wall, a fence, or some other improvised support. For this shot, I simply placed the camera on the bench I was photographing.

NIGHT SCENES

There's no clear cutoff between low-light photography and night photography, and both use the same basic principles—a tripod, remote release, and an ultra-long shutter speed being the key ingredients. However, night photography brings with it a number of unique challenges and creative opportunities. The primary challenges include focusing and composing in near or total darkness, and calculating the correct exposure.

In daylight, focusing your camera is a simple matter, whether you're relying on the camera's autofocus system, or focusing manually. When you are shooting at night, though, things get much more complicated. For a start, there is often insufficient light for your camera's autofocus system to work, so you'll have to focus the lens manually. Yet even this isn't straightforward as the low light levels often mean you simply can't see any detail in the scene through your viewfinder, so how exactly are you supposed to focus when you can't see what you want to photograph?

The answer is to estimate the distance from your camera to the main subject in the scene and set the focus manually. If you're shooting a landscape this is fairly easy—as the natural focus point is the horizon, all you need to do is set the lens to infinity focus. If the main subject is closer to the camera, setting an accurate focus point is much more difficult, especially if you can't see the subject to guess the distance to start with. In these cases, a powerful flashlight can be a great help as it will let you add temporary light to the scene to help gauge the distance.

Focusing is not the only issue you will have when it comes to photographing night scenes. When you can't see the scene you're photographing, composing a shot can be very difficult, if not impossible. However, as your camera will be on a tripod, the easiest way to get around this is to shoot some test frames at the highest ISO setting using the widest aperture your lens offers. This will give the shortest possible exposure time, enabling you to review your composition on the camera's LCD screen and adjust the composition as necessary. Once you have composed the image, you can set the aperture and ISO you want to use for the final shot and make your extended exposure.

Calculating the correct exposure

In low-light conditions, a camera's metering system is less reliable than it will be in daylight, and at night it can prove even more difficult. As discussed earlier, this is because it assumes that the scene it is photographing is largely comprised of mid-tones. At night, when there is little or no light, this is clearly not the case and the most likely outcome if you rely solely on your in-camera light meter is that all of your night shots will come out too light. The suggested meter reading will provide a starting point, but applying negative exposure compensation (-1 to -2) to an automatic exposure reading is a good start point.

However, if your camera's maximum selectable shutter speed is 30 seconds, and a longer shutter speed is indicated, this can make things difficult. If this happens, you have two options. The simpler of the two is to experiment with the shutter speed in Bulb mode using nothing more than trial and error. Extend the exposure from 30 seconds, taking additional exposures and doubling the exposure time with each shot (effectively increasing the exposure by one stop with each shot). Using the histogram on your camera's display as a guide, you will be able to get to the correct exposure time, although this will take time.

↗ 50mm, 3.2 seconds, f/8, ISO 100

→ 35mm, 4 seconds, f/11, ISO 100
Whether it's the desolation of empty streets (right), or the natural and man-made colors of night (above), taking your camera out when most people are sleeping is the perfect opportunity to record scenes that are both familiar, yet somehow remote from our everyday lives.

The alternative to this trial-and-error approach is to calculate the correct exposure time, although this requires a much better understanding of "stops" in terms of ISO, aperture, and shutter speed. Say, for example, that you want to take a shot at $f/8$ and ISO 100 but your camera indicates the exposure is beyond 30 seconds. Having set your desired aperture, increase the ISO until the shutter speed falls within the camera meter's range, making a note of how many ISO stops you need to adjust it by. In this example, let's say the shutter speed falls to 30 seconds at ISO 800. We know that the difference between ISO 800 and ISO 100 is three stops, so the correct exposure time at ISO 100 would be three stops more than it is at ISO 800. Therefore, if the exposure at ISO 800 is 30 seconds, it would be 60 seconds at ISO 400 (one stop), ISO 200 would require a 120-second exposure (two stops), and ISO 100 would need you to have the shutter open for 240 seconds, or four minutes (three stops). Having determined the exposure time you can set your camera to Bulb mode, the ISO to 100, and make the exposure, in this example for four minutes.

This is straightforward enough if the ISO alone gets you within the camera's 30-second limit, but when you're shooting at night this isn't always guaranteed. Even at the highest ISO setting your chosen aperture might require a longer exposure, in which case you need to adjust both the ISO *and* aperture, noting how many stops you adjust them in total. Following the previous example, let's say you wanted to shoot a scene at $f/22$, at ISO 100, and your digital SLR has a maximum ISO setting of 1600. If you find you get to ISO 1600 and the shutter speed is still more than 30 seconds, you need to start opening up the aperture. In this example, let's say that the camera indicates a 30-second exposure is possible at $f/11$ and ISO 1600. In total, you have increased the ISO by four stops (ISO 100–1600), and opened up the aperture by two stops ($f/22$–$f/11$)—a total of six stops. This means that the shutter speed at $f/22$ and ISO 1600 is six stops more than 30 seconds. You can now determine the exposure time by doubling the exposure for each stop adjustment, which gives a final exposure time of 32 minutes.

At very long exposures like this, photography isn't an exact science, so experiment with extended and reduced exposure times. You should bear in mind that significant adjustments will be needed to have a noticeable effect—with the 32-minute exposure used in the example above you would need to reduce the exposure to 24 minutes to make the image just half a stop darker, for example, or extend it to 48 minutes to lighten it by half a stop.

↑ 16mm, 5 seconds,
ƒ/5.6, ISO 100

↖ 90mm, 6 seconds,
ƒ/18, ISO 200

During the hours of daylight,
this highway near Shanghai,

China (above), or the
Madrid shopping center
(opposite) in Spain would
have much less appeal,
but at night they are both
transformed by the unusual
artificial lighting.

THE COLOR OF DARKNESS

At night, a scene can be so dark that it is impossible to tell what color anything should be. Often, you don't need to worry about this too much—assuming there will almost certainly be something in the photographed scene that is fairly neutral in color, all you have to do is take the image and then correct the colors post-capture. You can do this by altering the white balance of a Raw image when you process it, or by making color and hue adjustments to a JPEG file.

Alternatively, you can view night photography as an opportunity to be more creative. For example, if you are photographing a landscape at night, editing the image so that the sky ends up a deep shade of blue will probably produce an image with a greater sense of photo-realism, even though the sky looked black at the time. Alternatively, by altering the white balance in a more creative way, you can produce a range of different intterpretations that you may find more appealing, as the examples shown here demonstrate:

The subject is the same, but the color processing has produced three unique results, none of which can be said to be "wrong."

The simple rule at night is that no one knows what the "right" color is, so you have a free hand to create the most striking image, rather than a technically correct one.

↑ 22mm, 8 minutes, f/5.6, ISO 100
↗ 17mm, 6 minutes, f/5.6, ISO 100
→ 27mm, 8 minutes, f/5.6, ISO 100

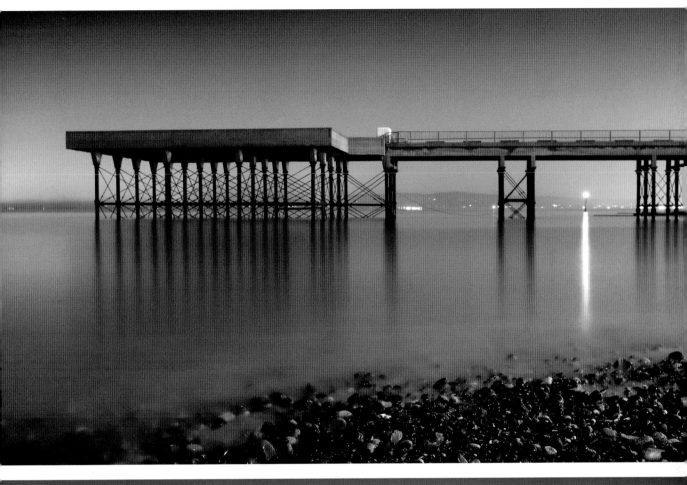
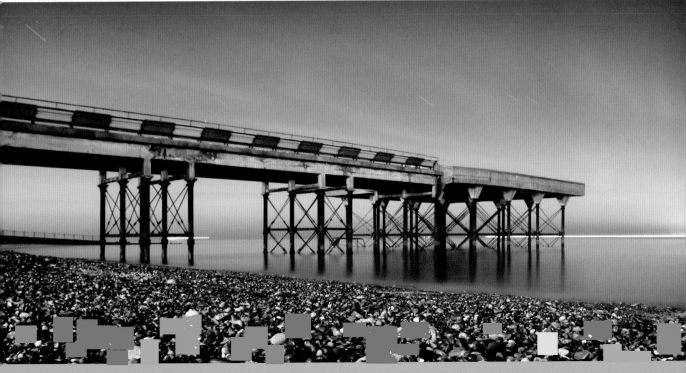

CITY LIGHTS

The technical considerations that you need to bear in mind when shooting city lights are broadly similar to the things you need to pay attention to when shooting in low light or at night, but in many ways these shots are much easier to take, not least because you can clearly see the scene you are photographing. However, you do need to be aware that evaluating the exposure of such scenes—and other night shots that contain bright light sources—can often be difficult because of the extreme high contrast.

Evaluating the exposure

We've already seen how to use the histogram to evaluate an exposure and avoid clipped highlights, but when you are photographing city lights some overexposure is often inevitable and can also be desirable. This is because the lights are a lot brighter than their surroundings, so if you adjust your exposure to try to prevent them from being overexposed, the rest of the image will often be too dark.

The extent to which you need to overexpose such shots varies, and if you are unsure as to whether any overexposure is necessary—or how much to add— I would suggest you shoot a series of bracketed exposures. For example, if the metered exposure is ten seconds at $f/8$, shoot two more frames: one at five seconds (one stop underexposed) and one at 20 seconds (one stop overexposed). That way you will be able to evaluate the images and decide which one you think works best.

One of the main problems with overexposing in this way is that the various light sources can end up looking like shapeless patches of light, and the final image can give the impression that you simply got the exposure wrong. One technique that can help with this problem is to add a subtle starburst effect (see page 77), where rays of light appear to fan out around each light source. This is very easy to do in-camera, and it can create a more attractive result.

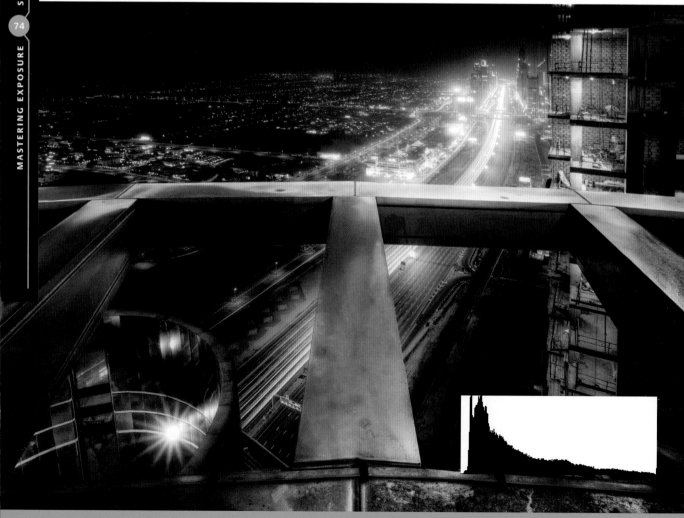

← 20mm, 20 seconds,
ƒ/16, ISO 100
Although much of the
histogram is shifted to
the left with this shot
(representing the large areas
of dark tones), the short
spike against the right end
of the graph indicates that

a small amount of data
within the scene has been
overexposed. However,
although technically the
highlights are "burned out"
they don't spoil the picture
because people accept that
pinpoints of light will be
bright in a scene like this.

↑ 28mm, 13 seconds,
ƒ/20, ISO 100
Just after sunset or before
sunrise, the natural colors in
the sky can reflect the colors
of artificial city lights. In this
view of Moscow, the deep
blue of the sky enhances the
coolness of the water and

the shadows, while the
orange glow echoes the
street and vehicle lights.

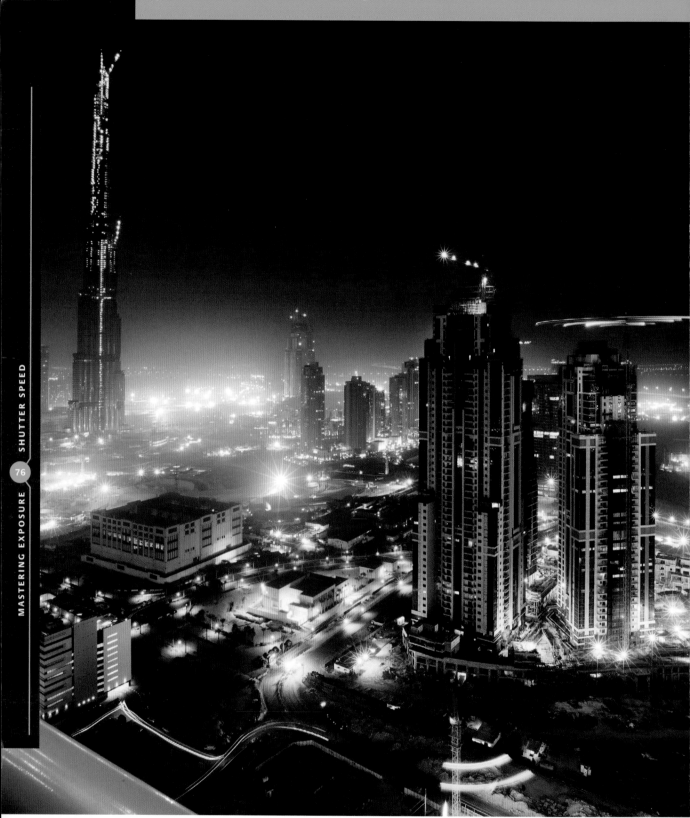

↑ 16mm, 30 seconds,
ƒ/16, ISO 100
As with the previous image,
the blown highlights and
blocked-up shadows enhance
the atmosphere of this shot.

A careful choice over the
exposure has also created
some interesting details.

OPTICAL STARBURST

Although you can buy a starburst filter, the easiest (and cheapest) way of creating these interesting highlight shapes is to shoot at a small aperture (f/16 or smaller). The small aperture causes the light to flare at the point in which the iris blades in the lens meet, creating a distinctive "star" effect around point sources of light. Usually, the number of "rays" formed for each star is equal to double the number of aperture blades in the lens, so if an aperture has six blades, there will be 12 rays. This technique doesn't work with lenses that have rounded aperture blades, or when the difference in luminosity between the light source and the background is small, but it is very effective with man-made lights in nighttime cityscapes.

LIGHT TRAILS

As well as setting the aperture to produce starbursts, you can use the shutter speed to add creativity to your nocturnal city shots, in this instance by shooting with a slow shutter speed so you record light trails left by moving elements such as cars and other vehicles. Shutter speeds of several seconds work really well, and long exposures such as this are a natural pairing to the small aperture settings required for starburst effects. For this shot, a 30-second exposure has not only recorded the light trails from the vehicles in the city streets, but also the movement of a rooftop crane. Selecting a slow ISO of 100 has helped maximize the shutter speed, while simultaneously minimizing the digital noise that is often associated with low-light photography.

↑ 24mm tilt-shift lens,
13 seconds, ƒ/5, ISO 50
For this cityscape, a tilt-shift
lens has been used to control
the plane of focus, so the focus extends along
the road, rather than
across it. This emphasizes
the light trails left by the
passing vehicles.

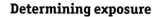

STAR TRAILS

One of the most fascinating aspects of night photography is star trails, in which the stars appear to rotate in the night sky. This motion is visible in both the northern and southern hemispheres, but it's much easier to compose a shot in the northern hemisphere because the stars rotate around Polaris—the North Star. This means you can position Polaris in the frame, knowing that this is the point around which all other stars will appear to rotate.

However, in the absence of any foreground detail, star trails will show up as little more than curved white lines against a dark background (hardly an inspiring photograph), so it's important to consider what else will appear in the frame. The star trail photographs that work best are the ones that contextualize the movement, either with an illuminated foreground, or a silhouette, such as a tree or a building, against the night sky.

Determining exposure

There are two things you need to consider when determining the correct exposure for a star trail shot; how bright the star trails should be, and how bright the remainder of the image should be. The first is controlled by the aperture and ISO, while the second is determined by the aperture, ISO, and shutter speed. The reason for this is that allowing more light to reach the sensor by increasing the aperture and/or increasing the ISO sensitivity will simply make the stars appear brighter—it will not affect the distance they move across the frame during the exposure. To control the length of the trails, you need to change the shutter speed; the stars will move a greater distance across the sky the longer the exposure time. The light within the remainder of the scene—the foreground, the sky, and so on—will be affected by all three exposure controls.

Shooting single exposures

Every scene is different, but, generally speaking, a good starting point for shooting star trails is an aperture of $f/8$ as this will typically deliver the best image quality from your lens and provide a depth of field that will be sufficient to cover both the stars and foreground, so both appear sharp. Wider apertures can be used when you want to reduce the exposure time, but because of the reduced depth of field this is best done when all of the elements in the scene are at the same focusing distance—"infinity" in the case of stars. Regardless of the aperture, set a relatively low ISO to minimize noise. Then calculate your exposure as you would for a normal night scene (see page 64), bearing in mind that the longer the exposure, the longer your star trails will be.

One problem you may encounter when shooting star trails with a single exposure is that the longer the exposure, the brighter the scene as a whole will appear. If you're shooting in a location that has minimal light pollution, this isn't an issue as starlight will probably be the only visible light in the scene. With most locations you will find that the extended exposure will result in an image where the foreground elements and/or the sky become overexposed.

A second problem is that the longer the exposure, the noisier the image will become—not because of the ISO setting, but because extremely long exposures will also increase the digital noise in an image. Fortunately, there is an answer for both of these problems: exposure stacking.

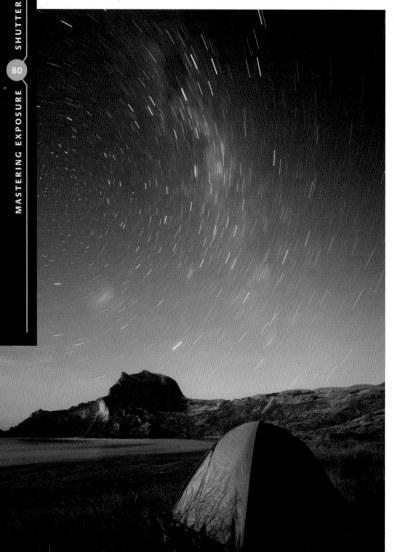

← 16mm, 8 minutes,
ƒ/3.5, ISO 400
A single, eight-minute
exposure taken in the
northern hemisphere.
The camera was aimed
in the direction of
Polaris, with the other
stars appearing to trail
around it.

↑16mm, 80 exposures,
30 seconds each,
ƒ/3.5, ISO 2000
While you can create star
trail images with a single,
long exposure, making
multiple exposures and
combining them in an
image-editing program
will help prevent a bright
foreground from burning
out, as well as reducing
image noise.

Exposure stacking

Put simply, a series of short exposures can be used to capture the same degree of movement as a single, longer exposure. For example, instead of shooting a one-hour exposure, you could shoot 60 one-minute exposures. The total exposure time will be the same, and 60 shorter exposures would capture the same movement of the stars. However, the ambient light would have much less of an effect on each individual image, meaning the contrast between the trails and the rest of the scene will be higher. Not only that, but as the individual exposures are much shorter they will contain less noise, allowing you to shoot at a higher ISO setting.

The easiest way to shoot a sequence of images for stacking is to use a timer that you can set to take a sequence of images lasting a specific length of time. If you don't have one of these (and most of us don't) you need to make sure that you trigger each exposure as soon as the previous one finishes, otherwise your star trails will be fragmented—although you could use this for creative effect.

Once you have shot your sequence of images, you need to combine—or "stack"—them in an image-editing program. Start with the first shot in the sequence, and add each subsequent exposure as a new layer. Change the blending mode of each additional layer to Lighten; as you do this, the length of the star trail in the image will appear to increase, without changing the brightness of the sky. Continue adding images until you've stacked your entire sequence.

A further advantage of using this method over the single-shot technique is that you can shoot additional exposures, optimized for the foreground and the sky. These elements can then be blended with the stacked star trails to create the finished picture.

↖ 35mm, 8 hours,
ƒ/22, ISO 100
Shooting in an area where there is no light pollution is essential if you want maximum clarity, as in this ultra-long exposure that lasted a whole night.

↑→ 24mm, multiple exposures
Once you've taken all your exposures, you'll have a number of different ways to combine them. Above is a more conventional treatment, but the image on the right adds a single frame of non-streaked stars. That single frame was achieved using a much higher ISO, but only the stars come through; the noise is cancelled out by all the other frames.

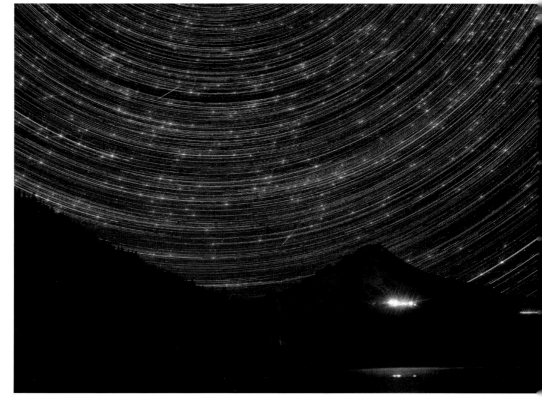

THE MOON

Of all the celestial objects you can photograph, the moon is one of the most interesting, not least because it's sufficiently large (and close) to be photographed in its own right. But it's also a difficult subject to photograph, as it often ends up looking disappointingly small, even if you use a telephoto lens. To fill the frame with the moon requires a focal length of at least 1200mm, and while these extreme lenses are available, they are very expensive.

A cheaper alternative is to attach your camera to a telescope. These can range in price from several hundred dollars up to several thousand, but many will allow you to attach a camera via a dedicated mount. From a practical point of view this is the equivalent to shooting with a very long lens. As such, the main consideration is to make sure that you keep the camera, tripod, and telescope as still as possible during the exposure—even the most minor movement will compromise image sharpness.

Choosing an exposure

Whether you shoot the moon through a telescope, or with a long lens, one thing you'll soon realize is it's a lot brighter than you might expect. A full moon has an EV of around 15—equivalent to a scene in full or moderately hazy sunlight. If you are filling the frame with the moon, you just need to select an appropriate exposure as you would for a shot in daylight. However, if you want to include anything else in your shot you will have a problem, especially if you are photographing the moon at dusk or at night.

The problem in low-light conditions is the short exposure required for the moon (EV 15) will mean everything else in the scene (which could be anything from EV 0 to EV 9) will come out extremely dark, or just plain black. In these situations, setting the exposure to capture the detail in the scene as a whole is the best option, especially when the moon only occupies a small portion of the frame.

However, it's worth remembering that the moon moves in the sky. For reasonably short exposures of a few seconds this movement is unlikely to be apparent, but if you extend the exposure to several minutes you will introduce some degree of motion blur. To avoid this, consider making two exposures and merging them in your image-editing program. Make one exposure to record the nighttime scene as a whole, and a second exposure to record the detail in the moon.

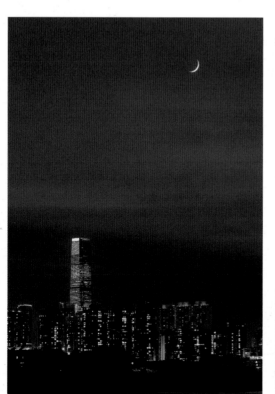

←↓ 22mm, 9.2 seconds, ƒ/16, ISO 100
At night, when the moon is a small part of an image, it will prove impossible to record all the detail in the dark foreground and the bright moon in a single exposure. In these situations, either let the moon "burn out" to white, or shoot two separate exposures and composite them in your image-editing program. Here, one exposure was made and the small, crescent moon was allowed to come out as pure white as the detail above shows.

→ 1250mm telescope, 1/125 second, ƒ/13.8, ISO 400
The moon is a lot brighter than you might expect, possessing an EV of around 15. This means exposure times can be surprisingly short when it fills the frame, as in this image, which was captured through a telescope.

FIREWORKS

While most of the topics we have discussed in this chapter present some unique technical challenges, in one important respect they are no different from the vast majority of photographic subjects. In each case, you are photographing a pre-existing scene, which means you can compose the shot, judge and correct the exposure, and reshoot if necessary. Photographing fireworks, on the other hand, is a radically different exercise because you need to trip the shutter *before* the subject (the explosion of color) has appeared, and each shot will be different to the last—there's no opportunity to reshoot if things don't go to plan.

Setting up

For most low-light and night scenes you can take your time and alter your shooting position if you need to recompose a shot. However, when shooting fireworks displays it is best to select a vantage point before the

display starts, so arrive before dark, check out the area, and decide if you want to include any static elements— such as buildings—in your images. When you shoot the display, these elements will probably be rendered as silhouettes, so look for structures with relatively identifiable shapes. Turning up early also means you can find a position that will be unobstructed by other people. It can be difficult to move around once the display starts, and as fireworks displays tend to be quite short, trying to find an alternative vantage point while the event is happening will waste time that could be spent shooting. It's far better to find the right spot early on.

Similarly, changing lenses can be a time-consuming process that will mean you miss some of the action, so select a lens that will be appropriate to your distance from the display, and its expected size, before it starts. A zoom lens definitely offers the greatest flexibility,

← 38mm, 1.4 seconds,
ƒ/16, ISO 100
↑ 17mm, 2 seconds,
ƒ/16, ISO 100
A great starting point for
fireworks photography
is an aperture of ƒ/16 and
ISO 100. Using your camera

in Bulb mode, open the
shutter for 1/2 second to
10 seconds, depending on
the number of explosions
you want to record. Here,
no more than 2 seconds
was needed to capture
these colorful bursts.

and if you're relatively close to the action, a standard
zoom covering a focal length range of 18–70mm (or
thereabouts) is a good choice. If you're farther away
you might need to use a telephoto zoom, such as a
70–200mm zoom, for example.

Technical considerations

Once you're in place, set your camera so you aren't fumbling around in the dark later. A good starting point is to set your camera to ISO 100, with an aperture between $f/11$ and $f/22$. As a general rule, $f/16$ will provide a good balance between the movement of the various light sources in the image, without overexposing any of the light trails too drastically.

In terms of shutter speed, using Bulb mode in conjunction with a remote release will give you the greatest control over exactly what gets included in each shot. Exposure times of between 1/2 second and 10 seconds are usually sufficient—any longer and you risk overexposure from the ambient light, any shorter and the fireworks will be tiny trails rather than full-blown explosions.

An alternative method for recording multiple fireworks—and avoiding overexposure—is to cover your camera's lens between explosions. Start the exposure by triggering the shutter in Bulb mode, then cover the lens immediately after the first firework (but do not close the shutter). To record a second explosion, uncover the lens when you anticipate it's being launched, then cover it again once the light has faded. Because your lens is covered between the bursts, the ambient light won't affect the image as much as it would if you just made a single long exposure, so you shouldn't suffer from overexposed images.

When you've finished recording as many fireworks as you want, close the shutter and repeat the process for your next shot. Remember: you can check the exposure of your first few shots using your camera's LCD screen and histogram and adjust the aperture if necessary, but fireworks displays don't last long so you need to think and act quickly.

↑ 52mm, 15 seconds,
$f/8$, ISO 100

→ 17mm, 9 seconds,
$f/16$, ISO 100

A long, single exposure will start to record the ambient light as well as the fireworks. This can work well in some situations, but if you want to avoid it, try "capping" the lens between explosions.

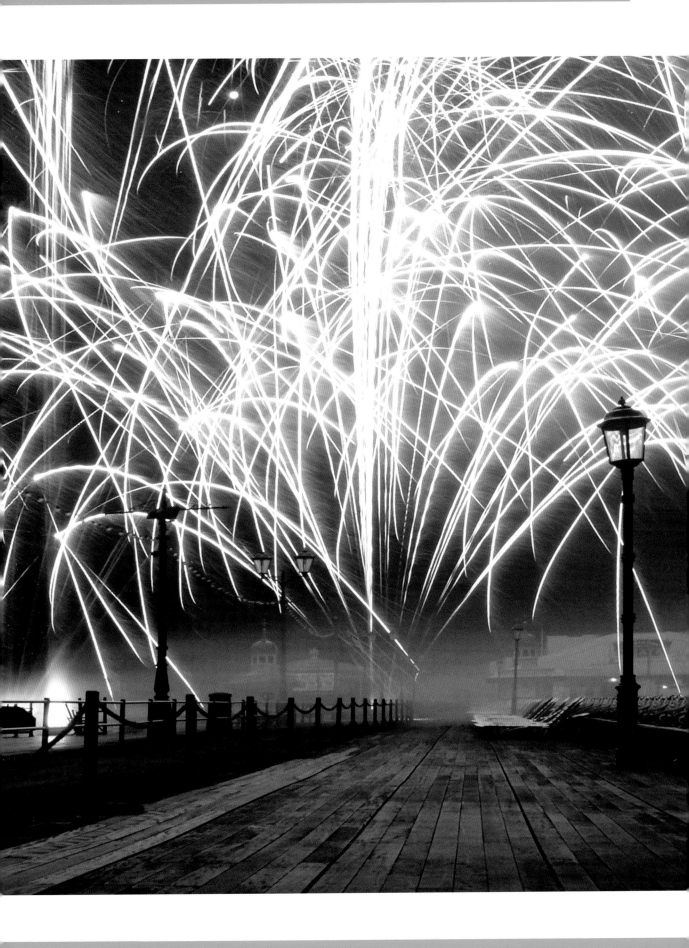

PAINTING WITH LIGHT

So far, we have focused on how to record the ambient light in low-light scenes, but here we are going to investigate a more proactive approach—adding targeted light to a scene. More commonly known as "painting with light," there are two main ways in which this can be done, but both require an ultra-long shutter speed so you've got enough time to add the additional light. For fairly simple scenes this might mean that you just need a few extra seconds, while for more complex images it's likely that you will need at least a couple of minutes. If you're shooting in total darkness you can leave the shutter open until you have added the light you need, but if you're shooting when the ambient light is brighter you will need to make sure that you control the duration of the exposure so the ambient light doesn't overpower the light you want to add. In most instances, this is simply a matter of shooting a few test exposures and determining the optimum aperture and shutter speed.

Painting with light using flash

One of the simplest forms of painting with light can be done using a conventional off-camera flash with a test-firing button. In near or total darkness, move around the scene, popping the flash to add light to different areas. In most cases, the result could also be achieved using multiple flash units, but painting with light has several important benefits. The first is that you can use a single flash, which means you can light an entire scene using one, inexpensive, low-powered device,

firing it more times, from different angles, to build up a more complex lighting array.

As a typical light-painted shot takes place over several minutes, you can move around within the frame as though you were invisible. This is because you will only occupy a specific area of the frame for very short periods, so your impact on the exposure as a whole will be negligible. In practice, this means you can place your flash within the frame and—providing it isn't pointing toward the camera—the way in which the light was applied won't be obvious. For example, you could add a burst of colored light to a small section of an image, confident that this won't spill over and illuminate other areas of the scene.

In principle, painting with light is relatively simple, but because each shot is different there are no hard-and-fast rules. As a guide, start by setting your camera to B (Bulb), select a low ISO (100 or 200), and set the aperture to f/8 and the flash to 1/16 power if it allows you to vary the output.

Then, open the shutter and move around the scene, triggering your flash to illuminate specific areas of the frame. Once the image has been taken you can use your camera's screen to see which areas have been properly exposed and which haven't. It will probably take a few goes to get the right amount of light on each area, and you might find you need to fire the flash several times, or increase its power to light some parts of the picture.

← 18mm, multiple exposures, f/5, ISO 100
First, there was one exposure to capture the star trails, several minutes long, then, a single 30–second exposure, during which numerous colored flash bursts were fired at different parts of the old stone structure. Compositing them in Photoshop was simple, and the effect is striking.

↑ 21mm, 30 seconds,
ƒ/11, ISO 200
This shot required some
visualization—and some
running. In the end it was
simple enough: run down the
corridor, painting with a
blue-gelled flashlight at
regular intervals along the
way, and then fire one
warm-gelled flash at the far
end, facing away from the
camera for a silhouette.

Painting with light using other light sources

While painting with light using a flash unit provides a high degree of control, seeing precisely where you will be "painting" is impossible. This means it's far easier to use a flashlight, which you can aim with much greater precision. You can also adjust its effect by varying the amount of time you spend on each area of the scene, the speed you move its beam through the scene, and its distance from the subject. The downside is a regular flashlight will not be as bright as a flash, so exposure times will need to be longer.

An extension of this technique—and one that produces a very different type of image—is to turn the flashlight around and point it toward the camera, rather than at the objects in the scene. Used in this way the light becomes a component of the image, rather than just a means of illuminating it, which can produce very interesting results.

You can use any sort of light to add this effect: a flashlight, an LED bulb, a sparkler—anything that acts as a light source. In practice, getting this type of shot right requires a lot of forethought, because you need to know exactly where you want the light to appear. Once you have decided, set a long shutter speed (or use your camera's Bulb mode), move the light through the scene to create the visualized effect, and then close the shutter. This is a technique that requires a lot of practice, but it's fun to try, and because the result is unrepeatable it's capable of producing unique images.

↑ 28mm, 30 seconds, ƒ/16, ISO 100
A single 30-second exposure, shot in a completely dark forest and illuminated using a sparkler. Care was taken to move throughout the entire area so that the snow and icicles would all be illuminated.

→ 35mm, 10 seconds, ƒ/13, ISO 100
If you have a subject that's willing to play with fire (i.e. a professional, trained fire dancer with all the requisite safety precautions), brilliant shots like this are quite simple—simply clamp the camera down on a tripod and meter on the illumination source—the shutter speed can vary wildly.

USING FILTERS TO EXTEND EXPOSURES

You have seen how to capture a variety of scenes using ultra-long shutter speeds, but most of the scenarios discussed so far share one common factor—the ambient light levels have been low, making extreme exposure times almost a necessity. However, there's no reason why exposure times can't be extended in daylight, so you can record movement in a subject, even in bright conditions. All you need is to reduce the amount of light reaching the sensor.

The easiest way to do this is by using a neutral density (ND) filter, or several ND filters in combination. Neutral density filters are constructed from partially opaque resin or glass and are designed to block a fixed amount of light, without affecting the color of the image (hence "neutral" density).

The amount of light a particular ND filter blocks is expressed in stops, with one, two, and three stop filters readily available from most filter manufacturers. Their effect is fairly self-explanatory; a one-stop filter lets you extend an exposure by one stop, or one EV (extending it from 1/30 second to 1/15 second, for example); a two-stop filter extends an exposure by two EV (1/30 second to 1/8 second); and a three-stop ND filter will let you extend the exposure time by three stops (1/30 second to 1/4 second). Some manufacturers produce much stronger ND filters—up to 13 stops in some cases.

ND filters are available as round, screw-in filters, or as square filters that can be mounted to your camera using a filter holder. While the screw-in variety tend to be cheaper, I'd recommend investing in a filter holder and one or more square, slot-in ND filters. While the holder and filter(s) might cost more initially, if you intend to use them with multiple lenses it's much cheaper to buy several adapters so you can mount them on each of your lenses than to buy screw-in filters that will only fit a specific lens diameter. A filter holder will also make it much easier to stack ND filters as you could use a 0.9 ND and 0.6 ND filter at the same time, for example, to reduce the light by five stops. Screw-in filters can also be stacked, but this can cause problems if you are shooting with wide-angle lenses as the rim of the front filter may be visible in the shot, creating vignetting (corner shading) in the final image.

Whether you choose screw-fit or slot-in ND filters, either alone or stacked, the filters themselves are very easy to use—simply attach them to your camera, compose your shot, and shoot as normal. Because your digital SLR's through-the-lens metering system takes the exposure reading through any filters that are fitted, there are no special exposure requirements. The only downside is that the image you see through your viewfinder will be darker because you are seeing through the filter(s). If this is a problem, compose and focus manually without the filter(s) attached, and then attach the filters and shoot as normal.

← 28mm, 30 seconds, ƒ/8, ISO 100
Long exposures of daylight scenes can also be an excellent method of making distractions disappear.

↗ 21mm, 30 seconds, ƒ/11, ISO 50
A 9½-stop neutral density filter extended the exposure time for this daytime shot to 30 seconds. Note the impossibly smooth surface of the water, which reflects the building behind quite nicely.

→ 15mm, 30 seconds, ƒ/11, ISO 100
Although water is the common subject for ultra-long daylight exposures, in this photograph a strong, 13-stop ND filter has provided an ultra-slow shutter speed that records the movement of the clouds, adding even more drama to the sunset scene.

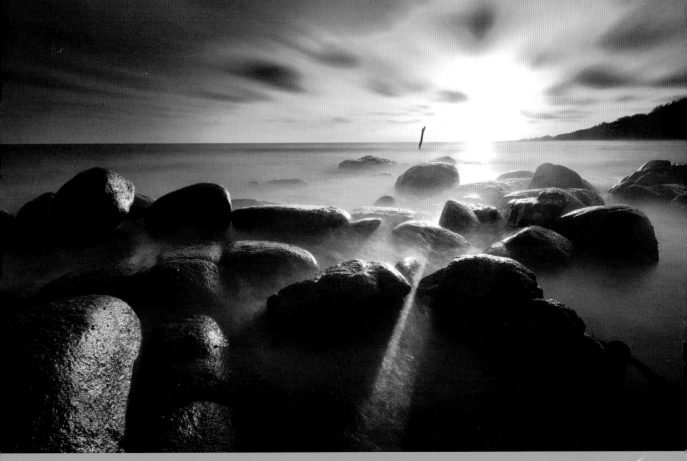

MOTION BLUR

Although we've concentrated on using an ultra-long shutter speed to create stunning imagery in a variety of situations, all of the techniques so far have one thing in common—the camera is locked down on a tripod or similar support. But there's nothing to stop you from liberating your camera, handholding it or loosening the tripod so you can introduce intentional blur into an image. By panning a static scene, rotating your camera during an exposure, or randomly moving your camera, you can deliberately introduce camera shake, creating beautiful, abstract, eye-catching imagery from even mundane subjects.

Panning

Panning a static scene immediately gives the impression that a scene is racing past the camera, as if photographed from a fast-moving train or car. The extent to which the final image will be blurred depends on two factors: the speed at which you pan and the duration of the exposure.

To produce a reasonably smooth image, mount the camera on a tripod, but loosen the head so you can make a slow panning movement in a single direction, with the shutter speed set between 1/4 second and 1 second (using Shutter Priority mode). Typically, the scenes that work best contain a strong horizontal or vertical component. If you pan a scene that is rich with detail, all you will end up with is a colored blur, but if you pan horizontally across a scene with a strong horizontal component—a seascape with a clearly defined horizon, for example—the horizon will remain relatively sharp and readable, but the colors will blend together to create smooth bands of color. Similarly, if you were panning a skyscraper, an upward or downward pan would emphasize the strong vertical lines created by the sides of the building.

Rotation

While panning a static subject can be effective, there's no reason why the camera movement can't be more disjointed—by rotating it during an exposure, for example. Rotation works best when the camera is relatively stationary for sections of the exposure, allowing it to capture some of the detail within the original scene. An exposure of several seconds gives you time to rotate the camera, hold it still, rotate it again, and so on, so set your camera to Shutter Priority, choose the lowest ISO setting, and set the exposure time to 2–4 seconds. Don't worry if the camera selects a small aperture as the depth of field is irrelevant—you will be moving the camera so the result is going to be deliberately blurred.

→ 60mm, 0.4 seconds,
ƒ/11, ISO 250
Panning horizontally during
a long exposure blends the
colors in this seascape image,
but the horizontal movement
doesn't disrupt the horizon:
The image still "reads" as
a seascape.

↙ 28mm, 2.5 seconds,
ƒ/22, ISO 100
This photograph of a
stairwell lit by fluorescent
lighting has been transformed
from an uninspiring concrete
construction into a mono-
chromatic abstract image
through rotation blur.

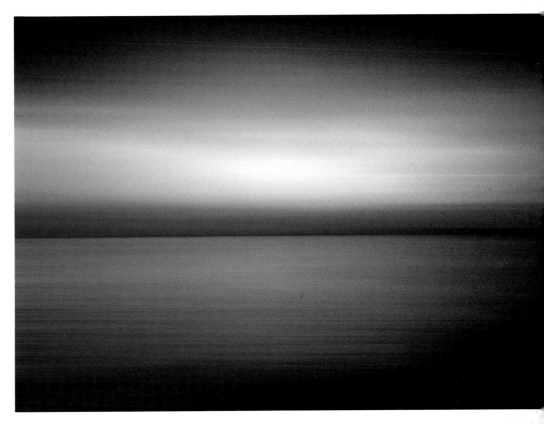

INTENTIONAL CAMERA SHAKE

Camera shake is something
photographers strive to avoid at
all costs, but it can be utilized to
create unique and striking images.
In this example, I set the ISO to 80
on a point-and-shoot-style camera
and attempted to hold it as steady
as possible during the resulting
13-second exposure.

Obviously, I didn't expect to get
a pin-sharp result, but the image
does show some identifiable
details. Other areas are blurred
beyond recognition, conveying
a much greater sense of motion
than would have been achieved
with a conventional exposure.

↑ 70mm, 4 seconds,
ƒ/4, ISO 100

Random movement

Most of the time, waving your camera around during an exposure will produce nothing more than a blurred mess, but with bright, point-light sources, this technique can transform them into an abstract trail of lights with the striking intensity of a Jackson Pollock "drip" painting. This example is the result of a 4 second exposure of the lights on a Christmas tree. By randomly moving the camera during the exposure, the lights appear to dance around the image, creating a purely abstract result. As with most of these techniques, set a long exposure in Shutter Priority mode so you have time to introduce enough motion into the scene to create an interesting image.

Aesthetic considerations

While the previous examples are interesting applications of motion-inducing techniques, most were shot without much thought about their creative impact. However, this final set of images (part of a much larger sequence produced by Christine Glade between 2008 and 2009), was created with a single aim: to use "intense color and movement" to capture the "energy, beauty, and vitality" of flowers in her husband's garden.

"By using a small aperture and long shutter speed, I was able to transform the flowers into something besides the petals and stems they normally appear to be. By sweeping across the flowers as the picture was being taken, and 'painting' with the camera, I became keenly aware that color—a wonderful thing to behold—is also a verb."

↗↗ 100mm, 1/2 second,
$f/29$, ISO 100

↗ 100mm, 1/6 second,
$f/9$, ISO 100

→ 100mm, 1/2 second,
$f/20$, ISO 100

PANNING

As well as using an ultra-short shutter speed to freeze motion, you can also help make sure the subject remains sharp by panning with your camera—a technique that can also come to your aid when the lighting means you have to compromise with the shutter speed. A creative offshoot of panning with a moving subject is that the subject will remain sharp, but the background can become blurred. This simple visual effect enhances the notion of movement and injects a sense of speed into an image.

Panning most likely needs no introduction—the basic aim is to track the movement of the subject as it passes the camera. This can be done with the camera mounted on a tripod, but make sure the tripod head is unlocked in at least one direction so you can turn the camera to follow the subject, or you can pan with the camera

handheld. If you choose to handhold the camera, stand with your feet roughly shoulder-width apart and turn your body from the waist to track your subject as it passes. This will produce the smoothest panning action, and in conjunction with lens-based or sensor-based stabilization it will mean you get the sharpest result. You also need to accurately track the subject, and make sure the entire exposure falls within the duration of the pan. The easiest way to do this is to start panning/tracking the subject as it approaches and then trigger the shutter when your subject is where you want it to be, and only stop panning once the shutter has closed.

→ 50mm, 1/10 second, ƒ/4.0, ISO 400
This kind of panning shot, when the subject is moving toward the camera, rather than horizontally in front of it along a single plane, is considerably more complicated. This was captured using a high-end continuous autofocus system, and by moving slightly back during the (still quite short) exposure—just long enough for the background to start to streak.

← 75mm, 1/30 second, ƒ/2.8, ISO 400
Panning is an effective technique regardless of the shutter speed you are using. For this shot, the exposure was a modest 1/30 second, but panning has recorded the subject sharply.

Speed & direction

Although panning is easy to understand and implement, there are some technical issues that need to be remembered. For a start, you should aim to pan with subjects that are moving parallel to the plane of your camera's sensor. This is because an object moving toward the camera will appear to increase in size, while one moving away will appear to shrink. Panning with a subject that remains relatively constant in size—one that is moving across the frame—is more likely to produce a sharp image.

You also need to think about the speed of your subject. It's easy to think that just using an ultra-short shutter speed will be enough to freeze *all* motion, but panning is still a better way of making sure very fast subjects remain sharp. For example, an object traveling at 100

mph will travel almost 2 inches (5cm) during a 1/1000 second exposure. This might not sound like a huge distance, but it's more than enough to take the edge off any detail if your camera remains stationary during the exposure.

In principle, the skills you need for high-speed panning are no different than those you need for low-speed panning—you just need to move a lot faster. For example, a racing car traveling at 200 mph will cover a distance of almost 300 feet (90 meters) in a second, so it will speed past you in the blink of an eye. Because of this, you will probably find your initial attempts at photographing fast-moving subjects are less than perfect. It's easy to miss the subject entirely or accidentally crop the front or rear of a vehicle, but persevere and you'll soon find yourself getting more hits than misses.

↓ 190mm, 1/30 second, *f*/25, ISO 200
Panning is all about tracking the subject for the duration of the exposure. Start panning before you trigger the shutter, and stop once the exposure has ended for the best results. The hardest part is to follow the subject while the viewfinder has "blacked out," but with practice this becomes easier.

→ 170mm, 1/500 second, *f*/8, ISO 800
Although the distance this motorbike would cover during 1/500 second isn't great, it would be enough to produce a blurred picture. Panning ensures the rider is as sharp as possible, while defocusing the background and enhancing the sense of speed.

↘ 40mm, 1/8 second, *f*/4, ISO 100
The best panning shots are those taken when the subject remains the same size in the frame—moving laterally in front of the camera rather than toward or away from you.

CHAPTER 3

APERTURE

"To me, photography is an art of observation. It's about finding something interesting in a ordinary place...I've found it has little to do with the things you see and everything to do with the way you see them." —Elliott Erwitt

Though the aperture doesn't provide anywhere near the same range of control as the shutter, at least not in terms of exposure (even an $f/1.4$ lens only covers a range of just eight stops), it plays a vital role in helping us to craft visually effective images by allowing us to vary the depth of field. We can create an image where everything is in focus—for example, a landscape, with a sharply focussed flower in the foreground through to a rich and detailed background—or we can focus the viewer's attention onto a key element within the frame: a person against what would otherwise be a distracting background, a single flower isolated among its peers, and so on. In this sense the aperture plays a vital role in allowing us to create images where we can shape the viewer's perception of the subject at hand, either by simply changing the aperture or by using a range of specialist lenses that afford us an even greater degree of control.

WIDE-APERTURE LENSES

In the most basic sense, a lens with a large aperture will let you shoot in lower light conditions with a reasonable shutter speed. For example, a lens with a maximum aperture of $f/1.8$ is two stops faster than an $f/3.5$ lens, so you could use a shutter speed of 1/60 second where the slower lens would require a 1/15 second exposure time, for example. As a result, the risk of a blurred image through camera shake is reduced. However, that's just the basic mechanics, and as we've seen already, the aperture directly controls the depth of field and this is where you can start getting creative with your picture making.

On the other hand, ultra-wide apertures will minimize the depth of field in an image, creating images in which subjects stand out from their background as their razor-sharp features contrast with their smoothly defocused surroundings. Unfortunately, wide aperture lenses come at a price, and fast, $f/2.8$ zooms or $f/1.2$ fixed focal length (prime) lenses, are always going to be more expensive than equivalent focal lengths with smaller maximum apertures. There are plenty of reasons why this is, but fundamentally, the glass lens elements need to be physically larger, so they cost more in materials, and the lens needs to be manufactured to tighter tolerances, meaning more "rejected" (and costly) materials. When you add in the lower demand for the finished product, the price needs to be increased to justify the existence of the lens. The bottom line is that wide aperture lenses often come attached to a prohibitively high price tag.

Fast, affordable, wide-aperture lenses

The costs involved in manufacturing wide-aperture lenses partly explains why modern digital SLRs often ship with a zoom lens with a maximum aperture of $f/3.5$–5.6—they're cheaper to make. Now, it's great that you can spend a fraction more than the price of a camera body and get yourself an SLR kit with a lens that can zoom from around 18–55mm (29–88mm equivalent on an APS-C sized sensor). But before you jump at this low-cost lens solution, you've got to realize one thing—that small maximum aperture *will* limit your creativity.

The simple reason for this is that a wide-aperture lens can create images that just aren't possible any other way, and when you start shooting "wide open" you're immediately going to be taking pictures that are different than most other people's. For example, you could get 100 photographers together in one place and they could all take a picture of the same scene at $f/8$, but how many could take the shot at $f/1.8$? Or $f/1.2$?

Despite noting that wide-aperture lenses are, as a rule, expensive, some are still most definitely affordable. For example, Canon's 50mm $f/1.8$ is around $115 at the time of writing, while Nikon's 50mm $f/1.8$ is about the same price. Given the benefits these lenses can bring to your photography in terms of their widest aperture setting, this already makes them a bargain, but if you're willing to put up with their idiosyncrasies, better value still can come from older, manual focus lenses—those "legacy" lenses that were once attached to film SLRs, but now find themselves in rummage sales or gathering dust on camera dealers' shelves.

→ 90mm, 1/100 second,
ƒ/2.0, ISO 400
Long subjects that
extend into the distance
away from the camera are
ripe for wide-aperture shots,
in which only a thin sliver of
the subject will be captured
in sharp focus.

← 50mm, 1/100 second,
ƒ/3.5, ISO 100
A fast, 50mm manual-focus
standard lens will typically
focus closer than a
contemporary zoom lens,
making for a high-quality,
low-cost close-up solution.

Legacy lenses

Maybe 20 years ago, if you bought a 35mm SLR the chances are it would have come with a manual focus, 50mm fixed focal length lens—universally known as a "standard lens." While this didn't have the versatility of a zoom, or indeed the advanced computer-aided design of modern lenses, it did have one major advantage— most of these lenses had a fast, $f/1.8$ aperture, while some boasted $f/1.4$ or even $f/1.2$ maximum apertures.

The good news for photographers buying digital SLRs today is that a number of camera manufacturers are still using the same basic lens mount they used on their film SLR cameras. Although the sophistication of the mount has evolved to accommodate advanced autofocus systems and provide increased communication between the camera body and the lens, the bayonet fitting has remained the same, which means many older lenses will fit—and work—on a modern digital SLR.

Nikon and Pentax digital SLRs, as well as those from Fuji and Samsung (which use the Nikon F and Pentax K lens mount, respectively) offer the easiest solution, as manual focus legacy lenses with the relevant mount will fit straight on to a digital SLR. Other manufacturers provide backward compatibility through lens adapters, such as the adapters that let you mount Olympus OM or Leica R lenses on a Four Thirds digital SLR, for example. Unfortunately, things are a little less positive when it comes to two of the leading digital SLR makers: Canon and Sony. While there are adapters available that will let their digital SLRs take older Canon FD and Minolta lenses (the precursor to Sony), the cost of the adapters largely negates the benefit, so you may as well invest in a modern, wide-aperture, fixed focal length lens to start with.

Which legacy lenses?

It's impossible to give a detailed list of which lenses work best with which cameras, and it's equally futile to work on the basis that if a lens is good on a 35mm film SLR it will work well on a digital SLR—sometimes, and for no obvious reason, this is not the case.

However, a great starting point is a 50mm, $f/1.8$ prime lens from a "known" manufacturer. For as little as $10 you can get yourself a great lens with a wide aperture that is capable of producing a very shallow depth of field. Not only that, but the magnification factor on an APS-C– sized sensor means the lens will have an effective focal length of around 80mm—perfect for portraits.

Modest telephotos also have their advantages, not least because the focal length will be extended by a factor of 1.5x or 1.6x on an APS-C–sized sensor (2x on a Four Thirds camera). As a result, a 200mm $f/4$ lens would behave like a 300–400mm lens (depending on the sensor size), which is a great solution for "slow moving" wildlife such as birds perched at a distance, or animals visiting a watering hole on a safari, for example. Plus, the cost will be a fraction of a modern lens covering the same focal length and aperture.

At the same time, though, it is generally a good idea to stay away from focal lengths of 24mm or shorter as these are likely to introduce unwanted artifacts at the edges of the frame. Manual zoom lenses are also best avoided—you generally do not gain any advantage in terms of the maximum aperture, and there are usually image quality issues as well. Zoom technology has come a long way since.

←← The 50mm lens is the "standard" for 35mm SLRs, and often has a fast f/1.4 aperture. Best of all, both manual and autofocus lenses can be bought for very little.

← Nikon and Pentax owners can mount legacy lenses straight onto their digital SLRs, but with Four Thirds digital SLRs like this Olympus, you need an adaptor.

↑ 90mm, 1/250 second, f/5.6, ISO 100
Macro is also well suited to legacy lenses because you're usually better off manually focusing anyway, because the depth of field at this degree of magnification is razor thin—even with narrow apertures.

Using legacy lenses

Although legacy lenses will fit your digital SLR, it's important to understand that using a manual focus lens that was developed in a pre-digital world is not going to be as simple as fitting the lens, pointing the camera, and taking a shot. Obviously, you will have to focus the lens manually, but this is just one of the problems you are likely to encounter. In some instances, the camera's exposure metering system might behave erratically, producing some shots that are correctly exposed, and others that are not. Alternatively, depending on your camera, it simply will not work at all. Assuming it does work, it's highly likely that you'll have to manually set the aperture you want to use on the lens, at which point the darkened viewfinder will make it harder to focus. Also, you might experience disappointingly poor results at some aperture settings, with sharpness falling off toward the edges of the frame, increased color fringing (chromatic aberration), and vignetting.

Yet while it might sound like there are a lot of reasons not to consider using legacy lenses, there are equally good reasons why you should. First off, a fixed focal length lens is much easier to optimize than a zoom, so a prime lens is a fundamentally superior design when it comes to achieving the best quality image. Also, if you are using a digital SLR with a non full-frame sensor (APS or Four Thirds) then you will only be using the center of the lens' imaging circle. This is critical, as the center of a lens is, optically speaking, the best part of the lens—it's the edges that are responsible for most unwanted artifacts. So, with a legacy lens, you are potentially using the best part of a superior lens design, which means a manual focus, 50mm, f/1.8 lens costing $5 in a yard sale can actually produce sharper images than a modern budget zoom lens covering the same focal length. Not only that, but you can take advantage of the wider apertures offered by these lenses to create shallow depth of field effects that are simply impossible to achieve with most zooms, unless you spend a small fortune.

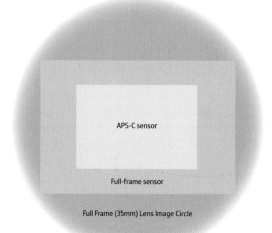

APS-C sensor

Full-frame sensor

Full Frame (35mm) Lens Image Circle

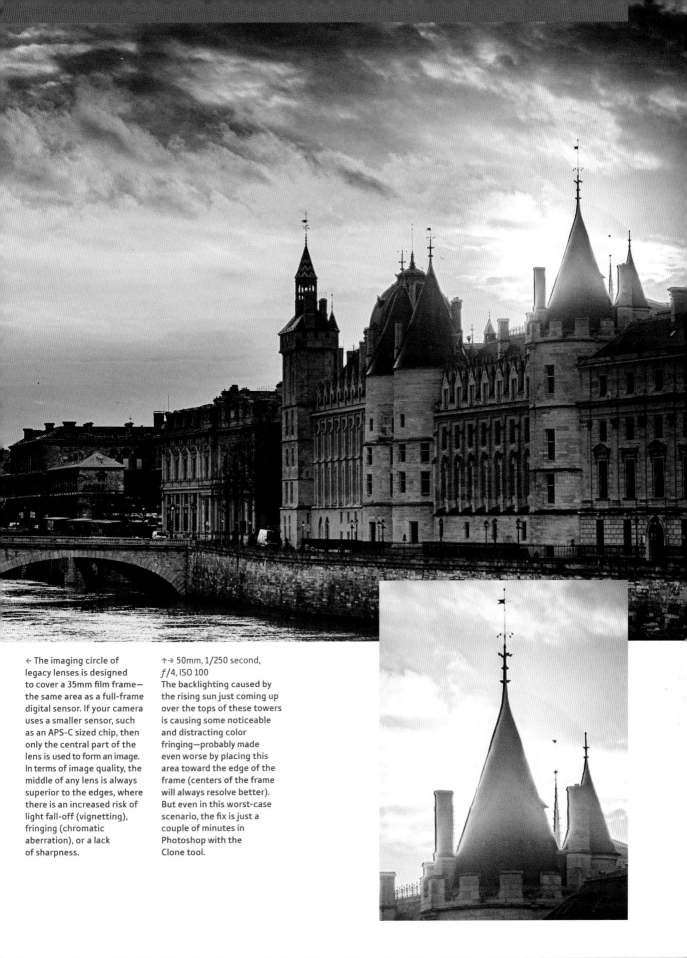

← The imaging circle of legacy lenses is designed to cover a 35mm film frame—the same area as a full-frame digital sensor. If your camera uses a smaller sensor, such as an APS-C sized chip, then only the central part of the lens is used to form an image. In terms of image quality, the middle of any lens is always superior to the edges, where there is an increased risk of light fall-off (vignetting), fringing (chromatic aberration), or a lack of sharpness.

↑→ 50mm, 1/250 second, f/4, ISO 100

The backlighting caused by the rising sun just coming up over the tops of these towers is causing some noticeable and distracting color fringing—probably made even worse by placing this area toward the edge of the frame (centers of the frame will always resolve better). But even in this worst-case scenario, the fix is just a couple of minutes in Photoshop with the Clone tool.

USING SHALLOW DEPTH OF FIELD

Many photographs are aesthetically stronger when only a portion of the image is in focus: for example, a portrait where only the subject's eyes are sharply defined, or a single flower isolated against its background to focus the viewer's attention. The key to success comes from precise control over the depth of field, which is determined by three main factors: the size of the aperture, the focal length of the lens, and the camera-to-subject distance. Wider apertures naturally have a shallower depth of field, but to illustrate precisely what effect they have, imagine you are shooting a portrait using a 50mm, f/1.8 lens, with your model standing 6 1/2 feet (2m) from the camera. With the aperture set to f/5.6, the depth of field in this scenario would extend from 5'9" to 7'7" (1.76m to 2.31m), so it will cover 22 inches (55cm). However, if you opened the lens up to its maximum aperture setting of f/1.8, the depth of field would immediately be reduced to just 7 inches (17cm).

You can also change the depth of field by using a longer focal length, as wide-angle lenses produce images with an apparently greater depth of field. Zooming in from a distance with a telephoto lens is a great way of reducing the zone of sharpness in an image, especially if you combine this with a wide aperture. Finally, if you really want to restrict the depth of field, you can decrease the camera-to-subject distance. Using the portrait example above, if you reduced the distance between the camera and subject so the subject was 3 feet (1m) away, the depth of field becomes a lot shallower. At f/5.6 it would cover 5 inches (13cm), while opening the aperture to f/1.8 would give a depth of field covering just 1 1/2 inches (4cm).

DEPTH OF FIELD TOOLS

With practice you will find that you develop a good grasp of depth of field, but there are many tools that are available that will calculate the precise depth of field for you. For example, I use PhotoCalc—an iPhone and Android app— although there are numerous online calculators available.

↓ 40mm, 1/2000 second, ƒ/4, ISO 100
A still-life image taken outdoors. The shallow depth of field prevents the background from detracting from the subject.

As this suggests, simply using a wide aperture is not the only way to obtain a limited depth of field—if you want as little of the subject in focus as possible, the best combination is a wide-aperture setting on a lens with a long focal length, with the subject placed close to the camera. Yet while the technical considerations are reasonably straightforward, the one thing to remember is that your focusing must be extremely accurate. If you are shooting a static object this isn't a major problem—you can take your time, assess your images, and reshoot if necessary—but when you are photographing something that might move at the moment you make the exposure you need to be far more careful. To be sure you get a sharp image in these situations, it is often best to either set a slightly smaller aperture and accept a slight increase to the depth of field, or consider taking a sequence of shots so you increase the chance of getting one with perfect sharpness.

In addition to the technical and shooting issues, there are a number of aesthetic considerations when you are shooting with a shallow depth of field. When a shot contains a single element that you want to isolate from its background, focusing is relatively straightforward, but when there is more than one element in a shot things become more difficult. For example, if you are shooting a portrait and the person is angled away from the camera, should you focus on the eye that's closest to the camera, their nose, or the eye farthest from the camera? Likewise, if you are shooting flowers from above, do you focus on the nearest one, the one in the middle, or the one farthest from the camera? There is no single answer to this, and like many aesthetic decisions, you should focus on the area of the image that *you* feel will give the final image most impact. If you aren't sure, try shooting a selection of images using different points of focus, and then pick the one you prefer when you review them at a larger size on your computer screen.

↖ 50mm, 1/100 second,
ƒ/1.8, ISO 100
Choosing the point of
focus needs to be carefully
considered when you're using
a wide aperture. For this
portrait, I chose to focus on
the eye closest to the camera.

↑ 90mm, 1/80 second,
ƒ/3.0, ISO 50
For this flower study I took
a selection of shots, focusing
at different points in the
frame. It is much easier to
choose one when you can see
them on a computer screen

than trying to assess depth
of field on your camera's
LCD screen.

How shallow should the depth of field be?

While it's often tempting to shoot an image with as small a depth of field as possible, this isn't always desirable. If you shoot "wide open" (at the widest aperture setting) the depth of field will be minimal, but the edges of the subject can become soft and start to merge into the background. So, if you are attempting to isolate an object from its background, it can often be better to set a slightly smaller aperture to make sure that all of the subject is in focus and the edges really stand out against the softer background, rather than shooting wide open. In these circumstances, it's a good idea to shoot a range of shots in Aperture Priority or Manual mode, working up from the widest aperture setting by two stops (f/2.8, f/4, and f/5.6, for example) and deciding which one works best when you see them on your computer.

It's also worth reiterating that it's not just the aperture that controls depth of field—subject distance and the focal length of the lens are also crucial. To take an extreme example, if you are shooting with a 100mm macro lens, and the object is very close to the camera, you will find that you actually need a very *small* aperture to obtain anything other than a razor-thin depth of field.

Even at the smallest aperture that such a lens can provide—f/22, say—the depth of field will still be relatively shallow, so be prepared to use a smaller aperture than you might anticipate with longer focal length lens, or a short camera-to-subject distance.

Ultimately, shooting an image with a shallow depth of field is definitely challenging. Not only do you need to decide what to focus on, but you also need to consider how much of the focused element should be sharply defined, and how blurred the background should be in relation to the remainder of the image. However, from an aesthetic point of view, wide aperture shots often have considerable visual impact and provide much greater scope for you to creatively control the content and appearance of your photographs.

↙ 200mm, 1/250 second,
ƒ/4, ISO 100
For this enchanting portrait,
a wide aperture with a long
focal length focuses attention
on a narrow band across the
center of the frame.

↓ 126mm, 1/640 second,
ƒ/5.6, ISO 100
Choosing the point of
focus is critical. Here, the
grasses would have been
unrecognizable if they were
blurred, but the distant boat
remains identifiable, despite
being heavily out of focus.

BOKEH

Bokeh is a term derived from the Japanese word for "blur" or "haze," which refers specifically to the nature of the out-of-focus areas in an image, particularly out-of-focus point-light sources. It is increasingly common to hear photographers discussing bokeh, often describing it as "good" or "bad," as though it's something you can specifically control, but you cannot—the effect is caused by the shape of the lens aperture, the physical design of the lens, and the extent to which the lens is corrected for spherical aberration. In short, the lens creates the bokeh, not the photographer.

Bokeh & aperture shape

When you shoot at anything other than the lens' widest aperture setting, any out of focus points in the image will take on the shape of the iris—the physical shape of the aperture the light is passing through. With some lenses, especially those with a high number of aperture blades, this results in the brighter areas within defocused parts of the image appearing as diffuse circles. However, most lenses have fewer blades in the aperture, which leads to polygonal irises, resulting in point sources of light in out-of-focus areas taking on the same multi-sided shape.

How lens design affects bokeh

Although the shape of the aperture has an effect on the bokeh shape, the design of the lens also has an impact. The most obvious example is a catadioptric, or "mirror" lens. Unlike a conventional (rectilinear) lens, light doesn't simply travel through what is effectively a tube containing glass elements. Instead, a catadioptric lens has a mirror in the center of the front element (hence the name "mirror lens"), which faces the camera's sensor. Light enters the lens around this mirror (heading toward the sensor), is reflected off a second mirror at the rear of

the lens, strikes the rearward facing mirror at the front, and is finally reflected back toward the sensor.

So how does this affect the bokeh? Well, because the mirror behind the front lens element blocks the central portion of the optical path, light enters the lens in a "ring" shape. This effectively becomes the shape of the lens' aperture, resulting in very distinct, ring-shaped bokeh.

Spherical aberrations & bokeh

A spherical aberration is an optical effect caused by the bending of the light rays as they travel through the lens, and it largely depends on whether the light travels through the edge or center of a particular element within a lens. A lens that is very well corrected for spherical aberrations will produce evenly illuminated bokeh, while a lens that is less well corrected may produce bokeh that is brighter in the center of the image than it is at the edges, or vice versa. Yet while different lenses will produce different forms of bokeh, evaluating the merit of different types is a purely subjective call—there are no objective criteria that can be used to say that one form of bokeh is better or worse than another.

↙ 40mm, 30 seconds, ƒ/4, ISO 100
↓ 70mm, 1/80 second, ƒ/3.5, ISO 200
Taken on two different lenses, the bokeh in these shots reveals different characteristics. In the night scene, the out-of-focus highlights appear as polygons, while the outdoor portrait exhibits much smoother, almost circular bokeh. This is primarily due to the number of aperture blades—seven in the lens used for the night shot and eight in the lens used for the portrait.

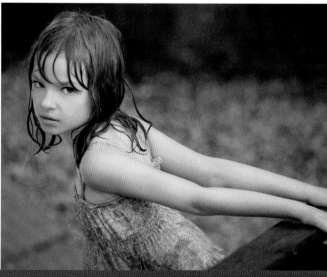

↑ 500mm mirror lens,
1/100 second, *f*/8, ISO 400
In and out of focus: the
telltale doughnut-shaped
bokeh of a catadioptric
(mirror) lens.

→ Here, you can see the
distinctive front element
of a catadioptric lens. That's
not a lens cap! Amazingly
enough, the center of the
lens' front element can be
covered by a mirror facing
the camera and still resolve
a clear image—albeit with
funky bokeh.

TILT-SHIFT LENSES: MINIMIZING DEPTH OF FIELD

We've already seen how conventional photographic lenses can be used to minimize depth of field, but there are other lenses that are also worthy of note in this regard; most notably, tilt and shift lenses.

Unlike conventional photographic lenses, where the optical path is fixed and light travels through the lens elements in a straight line, tilt and shift lenses let you modify the direction that the light takes. In architectural photography, the shift function is the more significant of the two, as it helps photographers avoid converging verticals so buildings remain upright, and walls remain parallel. However, in the context of ultra-wide apertures, the shift movement is fairly redundant as it only alters the perspective of an image and has no effect on depth of field.

Tilting, on the other hand, involves changing the plane of focus in relation to the film or sensor plane. There are two primary forms that this tilt can take—backward or forward. Tilting the lens backward is what we're most interested in here, as this movement will alter the plane of focus in such a way that the depth of field in an image appears to decrease at any given aperture.

As the accompanying illustrations show, because the lens is no longer focusing parallel to the sensor, the resulting picture will show a much narrower band of focus. Although the depth of field has not physically changed, its direction—and therefore its appearance—has, and the greater the backward tilt, the greater the effect. If a backward tilt is used in conjunction with a wide aperture, you can produce an image with only the tiniest sliver of sharpness across it, or you can use a smaller aperture to produce a selective focus effect. Either way, a tilt action can convert a wide aperture effect with a shallow depth of field into an ultra-wide aperture effect, with an ultra-shallow area of sharpness.

← A tilt-shift lens, such as this 85mm Nikkor, is ideal for controlling the apparent size and direction of the depth of field.

↓ As these illustrations demonstrate, applying a tilt with a tilt-shift lens has no effect on the actual depth of field. However, the tilt does change the plane of focus. Here, a backward tilt would mean that instead of the entire block being in focus (far left), only the top of the front face would be sharp, giving a "selective focus," or ultra-wide aperture look.

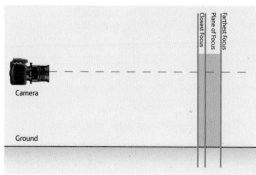

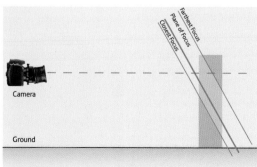

→ 35mm tilt—shift lens,
1/350 second, ƒ/5.6, ISO 1600
Narrowing the depth of field
with a tilt and shift lens makes
this shot far more interesting
than it would be if everything
was in focus.

↘ 90mm tilt-shift lens,
1/400 second, ƒ/8, ISO 125
Adjusting the plane of focus
gives an added dimension, as
the narrow zone of sharpness
runs at a slight diagonal
across the frame.

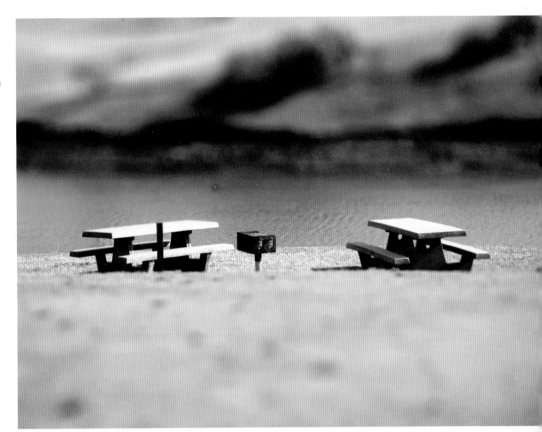

HYPERFOCAL DISTANCE

As we discussed in a previous section, there are three factors that contribute towards determining depth of field: subject distance, the focal length of the lens you're using, and the aperture at which you are shooting. The closer an object, the longer the focal length, and the larger the aperture, the shallower the depth of field will be. Alternatively, the farther away you focus, the wider the focal length, and the larger the aperture, the larger the resultant depth of field.

One area of photography where depth of field can be crucial is landscape photography, where you will often want to maximize the depth of field to include crisp and sharply focused detail in the foreground, through to a clearly defined horizon. One way to do this is to shoot with a wide-angle lens using as small an aperture as practical, but there is an additional way to maximize depth of field, i.e. setting your lens to the hyperfocal distance.

Put simply, hyperfocal distance is the point at which you should focus in order to maintain sharpness from as close as possible to the focal plane through to infinity. For example, imagine that you're shooting a landscape with a 24mm lens at f/22 and you focus on infinity. The depth of field will extend from 0.85m to infinity. This is good, but it's possible to do better. If you focus at the hyperfocal distance, which in this instance is 0.88m, then the depth of field will extend from 0.44m to infinity. In other words, by focusing at the hyperfocal distance rather than on the horizon, you have gained an additional 44cm depth of field.

The mathematically minded among you might want to look up the formula for calculating depth of field, but for the rest of us there are numerous online resources and smartphone apps that will simplify the process. Most just require you to enter your camera details, the focal length of your lens and the aperture you intend to use, and they will calculate the hyperfocal distance.

All you then need to do is focus your lens at this distance and take the shot. This is relatively straightforward if you have a lens with a distance scale, but if not then you'll need to either measure or estimate the focus point. If you have a measuring device, which can be something as simple as a tape measure or as complex as a laser range finder, simply find an object that's at the hyperfocal distance and then focus your camera on that spot. If you're using back-button autofocus then all you need to do is recompose and then press the shutter, but if your focus is linked to your shutter button, you'll need to switch to manual focus first.

Alternatively, pick a point that's as close to the hyperfocal distance as you can estimate. If you're unsure about the accuracy of your estimate, it's better to tend towards focusing beyond the hyperfocal distance rather than nearer to ensure that the horizon remains in focus. Alternatively, if you were intending to shoot at f/11, stop down to f/16 to increase the depth of field to compensate for any focusing inaccuracies.

↑ 20mm, 1/500 second, f/8, ISO 200
Keeping in mind that depth of field extends 1/3 in front of and 2/3 behind the actual plane of focus, it's important to realize that you're not actually focusing on the foreground in a shot like this, but rather just a few feet behind it—about where the wall is on the left of the shot above.

← 18mm, 1/250 second, f/8, ISO 400
Setting your lens to its hyperfocal distance is ideal for street shooting, as it takes the delay of autofocus totally out of the equation.

HYPERFOCAL DISTANCES FOR 35MM FULL FRAME

	16mm	24mm	35mm.	50mm	85mm
f/2.8	9.4ft (2.9m)	21.1ft (6.4m)	44.9ft (13.7m)	91.5ft (27.9m)	264.6ft (80.6m)
f/4	6.6ft (2m)	14.8ft (4.5m)	31.4ft (9.6m)	64.1ft (19.5m)	185.2ft (56.4m)
f/5.6	4.7ft (1.4m)	10.5ft (3.2m)	22.4ft (6.8m)	45.8ft (14m)	132.3ft (40.3m)
f/8	3.3ft (1m)	7.4ft (2.3m)	15.7ft (4.8m)	32ft (9.8m)	92.7ft (28.2m)
f/11	2.4ft (0.7m)	5.4ft (1.6m)	11.4ft (3.5m)	23.3ft (7.1m)	67.3ft (20.5m)
f/16	1.6ft (0.5m)	3.7ft (1.1m)	7.8ft (2.4m)	16ft (4.9m)	46.3ft (14.1m)

TILT-SHIFT LENSES:
MAXIMIZING DEPTH OF FIELD

In our earlier discussions, we noted that there are three factors that affect depth of field: aperture, subject distance, and the focal length of the lens. For most lenses, these are the only significant factors, but there is one additional type of lens that allows you to manipulate focus and depth of field in a different, and much more flexible way: a tilt-shift lens.

For most lenses, the plane of focus is parallel to the film/sensor plane, so any object that is also parallel to the same plane can be rendered sharply, even at wide apertures. When the subject is not parallel to the plane of focus—a receding landscape, for example—then the only way to ensure that it all remains in focus is to use a much smaller aperture to increase the depth of field.

Tilt-shift lenses, when tilted, allow you to "tilt" the plane of focus in relation to the plane of the subject. For example, if you tilt the lens down you shift the plane of focus to more closely match the subject plane of a receding landscape. Alternatively, tilting the lens to the side would allow you to achieve sharp focus along the entire length of a fence that is not parallel to the sensor plane.

In both cases, this can be especially useful. For example, if you were shooting a landscape at dusk the metered exposure might be something like f/2.8 at 1/30 second at ISO 100. To maximize the depth of field using a conventional lens, you might need to stop down to f/16. To do this you would need to increase the ISO to 3200, which would add an unacceptable amount of noise, or alter the shutter speed to 1 second. If there was no movement in the scene then the latter would be a good solution, but if you were attempting to photograph a field of poppies in a gentle breeze then a 1-second exposure would be equally problematic, i.e. there would be an unacceptable amount of motion blur. With a tilt-shift lens this problem can be sidestepped by tilting the lens down, shifting the plane of focus to match the field of poppies, enabling you to shoot the scene at a wide aperture, sufficiently high shutter speed, and a low ISO.

The relationship between the plane of focus and the plane of the subject and depth of field is described by the Scheimpflug principle, developed by Theodor Scheimpflug in the early 20th Century as a means of calculating focus for view cameras. The actual formula and calculations are fairly complex, but in essence, tilting a tilt-shift lens simply moves the plane of focus in relation to the plane of the subject.

In the above examples we considered how to increase depth of field by tilting the lens to more closely align the focal plane with the subject plane, but this isn't the only way you can use a tilt-shift lens.

As we discussed above, maximizing depth of field involves aligning the focal plane more closely to the subject plane. An alternative is to tilt the lens to misalign these planes. For example, imagine that you wanted to shoot a model and just have her eyes in focus, i.e. you want her forehead to be blurred, and her mouth, but not her eyes. To achieve this using a conventional lens you could shoot from above or below. If you shot from below using a wide aperture while focused on her eyes, her mouth would be out of focus as it would be in front of the focal point. Likewise, her forehead would be blurred because it's behind the focal point. Alternatively, you could shoot from above your model. In both cases, you would distort her features. Her mouth would appear too big (as it's closer to the camera), while it would seem too small if you shot her from above. By using a tilt-shift lens, and tilting the subject plane in relation to the focal plane, you could retain the correct proportions for her face while simultaneously blurring the detail both below and above her eyes.

Practicalities

While adding a tilt-shift lens to your camera bag can open up possibilities that are simply not possible with conventional lenses, they are expensive. For example, Canon's cheapest tilt-shift lens—the 45mm—is almost $1,700, while their 17mm T/S costs almost $3,500. Additionally, tilt-shift lenses are only available as fixed focal length lenses. Canon produce four, a 17mm, 24mm, 45mm, and 90mm, while Nikon have three in their range: 24mm, 45mm, and 85mm.

↗ In a reverse of what we discussed on page 120, here we see how to maximize depth of field. This may seem counterintuitive, as so much of what we've discussed in this book is about the aesthetics of shallow depths of field. Besides, why not just stop down the lens? Well, first off—tilting the lens in this way allows you to get incredibly deep depths of field at only medium apertures, and that's often where a lens is sharpest—when you start closing down your aperture to very narrow apertures, your image quality can suffer from diffraction. Plus, medium apertures mean you can use lower ISOs and faster shutter speeds in less than optimal lighting conditions. For instance, this dusk shot was quite dark, but managed to be shot at f/5.6!

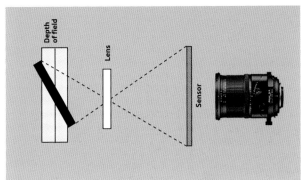

Depth of field

Lens

Sensor

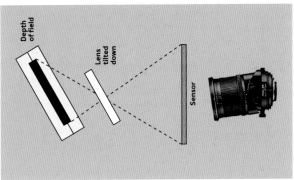

Depth of field

Lens tilted down

Sensor

Shifting a tilt-shift lens

In the discussion on the previous pages, I concentrated on the benefits and creative possibilities presented by tilting a tilt-shift lens, but this isn't the only way in which this lens can be used.

When you shift a tilt-shift lens, either vertically or horizontally, you shift the location of the lens' imaging circle relative to the digital camera sensor. The net effect is that the lens' center of perspective is no longer aligned with the image's center of perspective. This produces an image that could have been cropped from an image shot with a wider-angle lens. A good example of when this can be especially useful is when you wish to photograph a tall building. Using a conventional lens, in order to fill the frame with the building you would need to point your camera upwards, towards the vertical center of the building. The problem with this is that the verticals would then converge towards the top of the image, giving the appearance that the building was leaning backwards. By shifting the lens, you can effectively aim the camera at the vertical center of the building while keeping the sensor plane and subject plane parallel. In this way, the sides of the building will remain parallel.

↖↑ 24mm, 1/250 second, ƒ/5.6, ISO 400
In some cases, the difference caused by shifting the lens may be subtle. Here, you can really see the difference on the sides—on the left, the façades are falling away from the camera (because the camera is tilted up toward them); but on the right, the lens has been shifted up, and so it's keeping parallel with the vertical of the image.

→ 90mm, 1/500 second, ƒ/5.6, ISO 200
Architectural shots are always going to be a good choice for shifting your lens. The results appear more professional, and they help present the subjects in an idealized fashion.

THE LENSBABY

The Lensbaby has been around for a good few years now, and from its humble origins there are now three different models: the Composer, Control Freak, and Muse. Each lens operates in a similar way to a tilt-shift lens, allowing you to move the front of the lens relative to the film plane. However, a Lensbaby costs much less than a tilt-shift lens, and works in a slightly different way. Rather than changing a linear plane of focus, altering the position of the Lensbaby lens causes its "sweet spot"—a central area of sharpness—to move to different areas of the image. This sweet spot is surrounded by an area of blur, and the farther from the sweet spot, the blurrier the image becomes.

The Lensbaby range is entirely manual, both in terms of focusing and varying the aperture, which is achieved by dropping an aperture ring into the lens mechanism. The aperture can be varied from $f/2$ to $f/22$, but unlike a conventional lens a wider aperture doesn't give a shallower depth of field—instead, it produces a smaller sweet spot.

↑ The Lensbaby line up (left to right): Composer, Control Freak, and Muse.

← Lensbaby Muse, 1/8 second, $f/2.0$, ISO 100 Unlike a conventional lens, a Lensbaby produces a circle of relative sharpness known as the "sweet spot." Everything outside the sweet spot drifts off into a blur.

↓ Lensbaby Composer,
1/50 second, *f*/4, ISO 100
A Lensbaby is ideal for
isolating a subject from its
background. Using a wide
aperture creates a smaller
sweet spot, while smaller
apertures give a larger
circle of sharpness.

CHAPTER 4

FLASH PHOTOGRAPHY

"Light makes photography. Embrace light. Admire it. Love it. But above all, know light. Know it for all you are worth, and you will know the key to photography." —George Eastman

In the earlier sections of this book we discussed how to vary your exposures to make the most of the available light, but in this section we're going to concentrate on how you can add additional light to your images. We'll start by taking a look at the equipment you need and how to use it, then will move on to investigate how to use flash to supplement the available or ambient light, an indispensable technique for many forms of photography.

From there we'll move on to take a look at how you can use flash to freeze movement using conventional strobes before moving on to investigate the fascinating world of high-speed flash photography: a technique that can be used to freeze even the most rapid of movements.

FLASH EQUIPMENT & TECHNIQUES

One of the biggest problems with using an ultra-short shutter speed in daylight conditions—especially with a small aperture—is that there is often not enough light. Although you can raise the ISO (and reduce image quality), an alternative is to add light to the scene using a flash.

Dedicated flash units

A "dedicated" flash is the simplest and most versatile type of flash to use as it is designed to communicate with the digital SLR body (and lens) to determine the optimum exposure. It does this using an advanced form of through-the-lens (TTL) metering, such as Canon's E-TTL II flash metering, or Nikon's i-TTL. Both operate in a similar way: by firing a brief pre-flash that is read by the same in-camera sensor that measures the ambient light. The pre-flash exposure information is evaluated in conjunction with the lens-to-subject distance and used to calculate the ratio of the flash to the ambient light. In a split second, this determines the output of the flash.

Manual flash units

Unlike a dedicated flash, a manual flash unit doesn't necessarily communicate with your camera, which means you have to take more control. With some manual flashes there's the option of changing the power output, but with others there is not—either way, it's all about setting the right exposure for the result you want.

The easiest way to do this is by using a flashmeter, which will measure the light from the flash and tell you the aperture you need to use at any given ISO. The reason the flashmeter will tell you the aperture to use—rather than giving you an aperture and shutter speed combination—is because the aperture is considerably more important in terms of determining the overall exposure when you're using flash. This is because the duration of a flash unit is extremely short; something on the order of 1/3000 second at full power. If the flash is the sole source of illumination (in a blacked-out room, for example), the camera's shutter speed is irrelevant, as the flash will fully expose the subject in 1/3000 second, regardless of whether you set a shutter speed of 1/250 second, or 2 seconds. Where the shutter speed comes into play is when flash is mixed with ambient light. In these situations, the flash exposure is still ultra-short, but the shutter speed determines how much of the ambient light is recorded. A 1/60 second exposure will allow twice as much of the ambient light to reach your sensor as a shutter speed of 1/125 second, for example. In this way, the aperture controls the flash exposure, while the shutter speed controls the exposure for the ambient light.

↙ **Manual flash and flashmeter.** Although you can control the power of some manual flash units, the exposure is something you may have to work out yourself. This can make a flashmeter invaluable.

↓ **Nikon Speedlight SB-900.** Dedicated flash units, such as this Nikon Speedlight, communicate with the camera to determine the optimum flash output based on the ambient light, subject distance, and more.

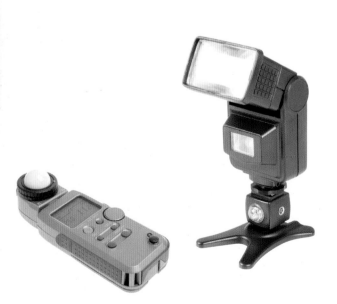

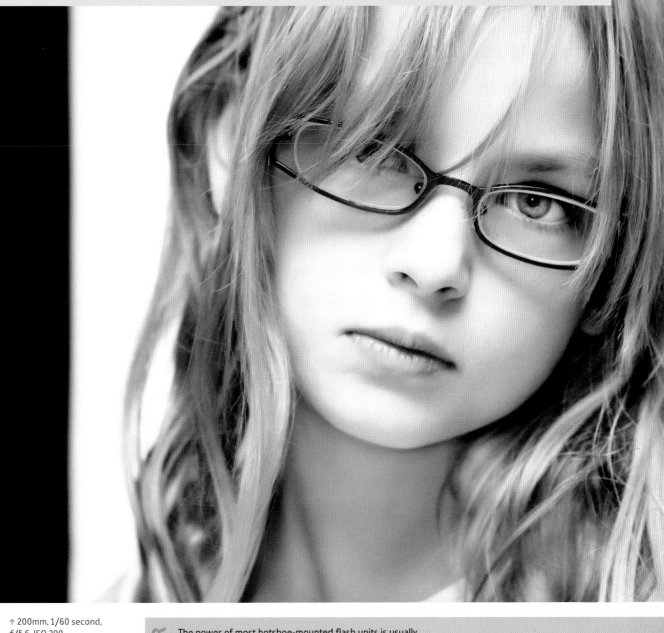

↑ 200mm, 1/60 second,
ƒ/5.6, ISO 200
The E-TTL II metering in
a Canon digital SLR meant
I could use a dedicated
Canon 580EX II flash and
let the camera determine
the correct exposure.

FLASH POWER

The power of most hotshoe-mounted flash units is usually
expressed as a guide number. For example, the Canon Speedlite
580EX II has a guide number of 190 feet (58m) at ISO 100. This
means the flash is capable of illuminating a subject 190 feet (58m)
away when it is switched to full power, using an aperture of ƒ/1.0
and ISO 100. The formula for deriving guide numbers is simple:

Guide number = distance × aperture

Although the guide number is based on a theoretical aperture of
ƒ/1.0, it can still be used to determine the ideal aperture setting
for a flash exposure—simply divide the guide number by the shooting
distance. For example, if your flash has a guide number of 190 feet
(58m), and your subject is 19 feet (5.8m) away, you would need to
use an aperture of ƒ/10 (at ISO 100). Just remember that the guide
number is almost always calculated in meters, so you'll need to
keep your the system of measurement constant when making
your calculations (i.e., either convert the guide number to feet,
or convert the distance to meters).

Off-camera flash

The main problem with your camera's built-in flash, or even a hotshoe-mounted flash, is that it points directly at your subject and is close to the camera's lens, which can result in harsh lighting and red-eye, to name but two problems. The light also dissipates with distance, so an object 6 feet (1.8m) from the camera receives only 1/4 of the light that would hit an object 3 feet (0.9m) away. Likewise, an object 12 feet (3.6m) away receives only 1/16 of the light. Known as the "inverse square law," this is the reason why using direct, on-camera flash can result in a perfectly illuminated foreground, but a very dark background.

There are a number of ways you can avoid this. If your flash has a head that will move, you can bounce the light from the ceiling or a wall, for example, which will help prevent red-eye. As you are effectively increasing the distance it travels, this will also make it softer and more diffuse.

Alternatively, you can move the flash away from the camera. This will revolutionize the creative scope of your flash, allowing you to light a subject from the side, from behind, from below—in fact, from wherever you can position the flash. The main ways of getting your flash off-camera are to use a dedicated flash cable (which restricts the flash position to the length of the cable) or a wireless trigger. Wireless triggers can range from optical slave cells that fire the flash when another flash is detected (such as your camera's built-in flash), through to infrared remote triggers and radio transmitters.

⊾ There are a variety of ways that you can use your flash off-camera, including optical slave cells (below), wireless triggers (left), or dedicated flash control cables (center).

↑ 200mm, 1/250 second, ƒ/13.0, ISO 100
For this portrait, I used off-camera flash to light the subject. Because of the flash-to-subject distance, the flash needed to be set manually to 1/8 power.

COLOR TEMPERATURE

Different light sources have different color temperatures, but a flash is designed to output light at a consistent color temperature of 5500K (degrees Kelvin). This is roughly equivalent to the color temperature of sunlight at noon, which means the color temperature of the ambient light and flash will be balanced (i.e., look natural together) if you're shooting under the midday sun.

However, using flash at other times of day, when the ambient light appears either warmer or cooler, or shooting under a different ambient light source, such as domestic tungsten lighting, for example, can reveal a noticeable and distracting disparity between the two light sources. If you want to avoid this, use a colored gel over the flash so it is matched to the ambient light source. For example, if you are shooting an indoor scene lit by tungsten lamps, use a CTO (Color Temperature Orange) filter over the flash to match it to the tungsten light, and use a tungsten white balance setting in the camera. It's also worth noting that LED lighting technology continues to advance by leaps and bounds, and high-end LED equipment can be fine-tuned to match a wide range of color temperature, negating the need to filters.

MIXING FLASH & AMBIENT LIGHT

Unless you are shooting in total darkness, most flash exposures will require you to balance the flash with the ambient light. If you're using a dedicated flash, your camera's TTL flash metering system will do a good job at getting the overall exposure right, but the tendency is to produce an image that clearly looks like it has been lit by flash. So, if you want the flash to be less obvious—to add catchlights to a subject's eyes without the flash dominating the picture, for example—there will be times when you need to take more control, and you can do this either by using flash exposure compensation, or by switching your camera and flash to manual.

Flash exposure compensation

If you want to decrease the flash power to produce an image where the flash is less dominant, but still contributes to the image as a whole, flash exposure compensation is the easy answer. Like your camera's exposure compensation feature, it adjusts the exposure, but rather than altering the shutter speed or aperture, it adjusts the power output of the flash—simply dial in -1/2 EV of flash exposure compensation and you immediately reduce the intensity of the flash by half a stop, for example. With some digital SLRs this is something that you control from the camera, while others might need you to make the adjustment on the flash unit.

However, flash exposure compensation isn't just about reducing the effect of the flash—you can also exaggerate its impact by dialling in positive flash exposure compensation. Alternatively, if you leave the flash at its default value and decrease the exposure for the ambient light using minus *exposure* compensation you can darken the background (the ambient light), and enhance the flash. This can be an effective way of drawing the viewer's attention to the flash-lit areas of an image.

Working in manual

For the greatest degree of control over your images, nothing beats switching both your camera and flash to manual. A flashmeter is essential as you need to set the power output on your flash, and determine exactly the right combination of aperture, shutter speed, and ISO to record the ambient light. This also makes it a time-consuming technique, but the advantage is absolute control over your lighting and the ratio between the ambient light and flash.

⬐ 50mm, 1/640 second, ƒ/6.3, ISO 50
Shot using the metered exposure and -2/3 EV flash exposure compensation to produce an image where the ambient light is recorded faithfully, and the contribution of the flash is less obvious.

↓ 24mm, 1/1250 second, ƒ/4.0, ISO 100
Shot using -2/3 EV exposure compensation, without flash exposure compensation. As a result, the background—lit by the ambient light—has been underexposed, while the flash has delivered the correct exposure for the subject.

↓ 85mm, 1/125 second, ƒ/10, ISO 100
This was shot in manual mode, using an aperture of ƒ/10. The subject was lit by one off-camera flash unit set to deliver the right amount of light for the aperture setting, but a shutter speed that would underexpose the ambient light on the background by two stops was deliberately chosen.

FLASH SYNCHRONIZATION

The fastest shutter speed you can use with flash on most SLRs is limited to around 1/200 second or 1/250 second, which is often referred to as the camera's sync speed. Using flash with a shutter speed that is faster than the sync speed means the sensor will only be exposed to a "slit" of light as the shutter opens and closes. This will leave the rest of the image underexposed, unless your camera is capable of high-speed synchronization as outlined opposite. At slower speeds, however, there is more time for the flash to fire, and in these situations you can decide when it is triggered—at the start of the exposure as the shutter opens, or at the end, just before it closes.

First-curtain sync

The default setting for most cameras is to fire the flash at the earliest opportunity after the exposure has been started. Termed first-curtain sync, this is fine for most situations, but when you are using longer shutter speeds with moving subjects it can lead to images that look slightly strange. The reason they look strange is because the flash immediately "freezes" the subject, but the ambient exposure continues to record the movement. As a result, the subject will be sharp and well-lit at the start of the exposure, but there will be a blur that

appears in front of them as they move. As we perceive motion blur as something that trails behind a moving object—not something that appears in front of it—this can look unusual.

Second-curtain sync

For more natural-looking motion in flash photographs, you should switch your flash to second-curtain synchronization. In this mode, the flash is triggered just before the exposure ends. This means any movement is recorded by the ambient light first, with the flash freezing the subject at the end of the exposure. Any blurred movement will appear behind the subject, effectively creating a "speed blur."

Second-curtain sync is slightly more difficult to use than first curtain, simply because you need to estimate where the subject will be at the end of the exposure, when the flash fires—not easy when your SLR's viewfinder blacks out as the exposure is being made. Consider adjusting your composition to accommodate this, or zoom out or step back so the subject has more space in the frame. You can always crop the image later.

← 20mm lens, 1/6 second, ƒ/14, ISO 100, first-curtain sync

↑ 18mm lens, 1/15 second, f/4.0, ISO 160, second-curtain sync

An additional form of flash synchronization that you might come across with some flash units is High-speed Sync. In this mode, the flash remains illuminated throughout the exposure by emitting thousands of low-power flashes per second, instead of a single burst of light. The short, high-speed flashes merge together so the camera's sensor is evenly illuminated, even when the exposure time is much shorter than the camera's sync speed. One classic use of high-speed sync is to get fill flash on a subject in bright lighting conditions that require shutter speeds well beyond the sync speed. The tradeoff, however, is a significantly decreased power output from the flash, so you generally need to get very close to your subject.

FREEZING MOVEMENT WITH FLASH

As the duration of a typical burst of flash is very short, this makes it a great tool for freezing movement, especially when the ambient light levels are low. However, it is not without technical problems. Imagine, for example, that you are shooting in reasonably bright conditions. You want your main subject to be primarily flash-lit, but you also want the background to be quite dark. You can control the amount of ambient light reaching the camera's sensor by adjusting the shutter speed, but the flash will be limited to your camera's maximum sync speed, which might not be fast enough to darken the background sufficiently. In this case, the obvious option is to decrease the size of the aperture—from $f/5.6$ to $f/11$ to reduce the exposure by two stops, for example. This would work, were it not for one major stumbling block—changing the aperture will affect the flash exposure, and you might find your flash cannot produce enough light to give a full exposure. This

means you either need to use a more powerful flash unit, move the flash closer to the subject, increase the ISO on your camera, or wait until the ambient light level is lower.

The best option is to wait: when the light levels are lower, your ability to control the ratio between the ambient light and flash dramatically increases. For example, the EV value of a typical scene just after sunset is around 9 EV. When shooting at 1/250 second, the aperture you would need to capture the ambient light would be $f/1.4$. Setting an aperture of $f/2$ would allow you to underexpose the ambient light by one stop, $f/2.8$ by two stops, through to five stops underexposed at $f/8$. This increases the potential you have to creatively manipulate the amount of ambient light you record, letting you underexpose by a small amount to focus the viewer's attention on a flash-lit subject, or "cancel out" the ambient light entirely.

← 300mm lens, 1/125 second, $f/11$, ISO 200
This shot was taken at dusk using two flash units—an on-camera flash set to 1/2 power, and an off-camera flash set to 1/4 power, triggered by a radio transmitter.

→ 15mm, 1/250 second, $f/5.6$, ISO 200
Flash isn't just a tool for freezing movement—it can also be used to add drama to a photograph, as in this urban setting. Getting close to the subject with an ultra wide-angle lens and then setting the camera so the flash dominates the background helps create a gritty look.

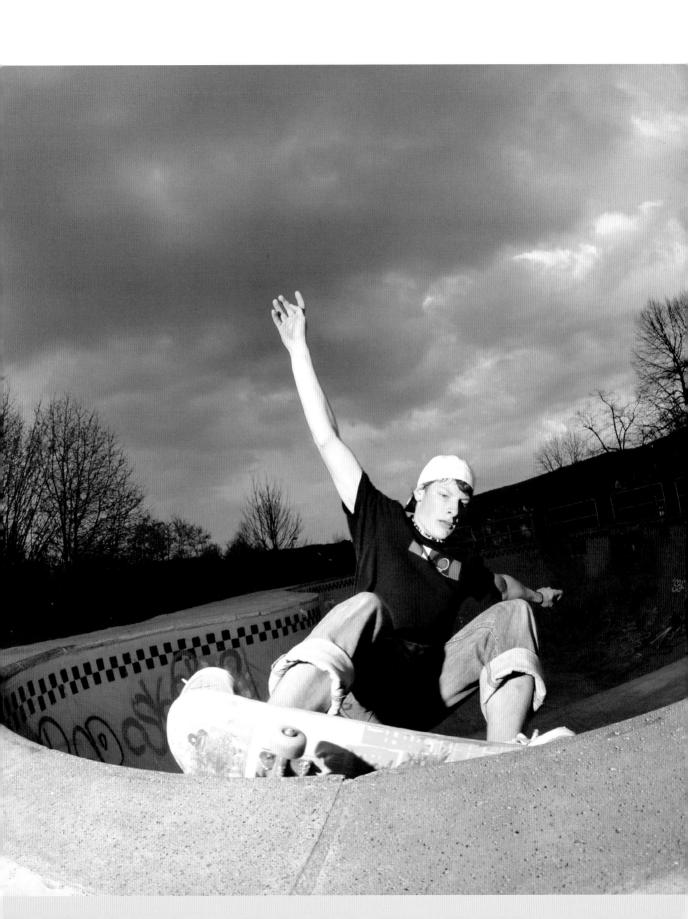

A shot in the dark

When you shoot in very dark conditions, your scope for lighting a scene—and freezing the movement within it—is greatly enhanced, simply because the ambient light will have a negligible effect on the exposure. This puts you in a position where the only light present is that which you add yourself, giving total control over the quantity of light, its direction, its color, the diffusion, and so on. With the advent of digital cameras this process is made very easy because you can consult your camera's screen after each shot and adjust the lighting.

Although using a single flash is where most people start, using more than one flash is a step toward greater creativity. However, multiple flashes also increase the complexity of a shot, especially if you are using individual flash units to light different components within a scene. Not only do you need to adjust the power, distance, and direction of each flash individually, but you need to make sure that all the flashes fire at the same time, using either synchronization cables or wireless setups.

Light painting with a flash can also freeze movement, and it doesn't matter if you're using a single flash or multiple units. While the aim is to freeze the movement within a scene, the technique is exactly the same as discussed on page 62. You can either attempt to shoot a single, extended exposure and add multiple bursts of discrete light to the image, or you can shoot a range of different exposures that you can combine during post-production, as in the example shown here. Shooting separate exposures might sound like "cheating," but it's much easier to get things right if you're shooting individual pictures than trying to build up a single exposure using multiple flashes.

→ 20mm, four exposures,
ƒ/4, ISO 100
This image was constructed from four exposures. The first included the figure holding two flash units, while the remaining three were taken using a single flash to freeze the chair in different positions in the air.

HIGH-SPEED FLASH

Although a typical flash duration is extremely short, the burst can be made even shorter if you lower the power output. This means you can freeze the most rapid movement, such as the splash of a water drop or the split second that a bullet pierces a balloon. Photographing this sort of subject is challenging for a number of reasons, not least because it requires absolute precision if you want to capture an event that lasts only a fraction of a second. For example, you could watch a bottle being broken by a hammer, but with the naked eye it would be impossible to identify any exact points within the sequence—when the hammer first touches the bottle, when the debris has traveled 6 inches, and so on—simply because it happens too fast for our eyes and brain to register these moments. Photographing it is harder still, as we not only have to "see" the moment,

but also react to it and trigger the camera. In addition to our reaction speed is the time it takes for the camera to fire. With a digital SLR this comes down to the speed at which the mirror can be swung out of the way for the shot to be taken. This may seem instantaneous, but the reality is that it takes somewhere between 40 milliseconds (1/25 second) and 100 milliseconds (1/10 second). Add in your reaction time and the overall delay can mean the difference between getting the shot and missing it.

This would suggest that tripping the shutter at the exact right moment is more about luck than judgment and, for some people, using luck to capture the "perfect moment" is part of the fun. However, for those who don't want to rely on serendipity there is a more technical solution—you can use an automatic triggering system.

← 180mm, 1 second,
ƒ/9, ISO 100
This photograph was shot using a light sensitive trigger and delay.

→ 105mm, 1 second,
ƒ/13, ISO 200
Relying on luck alone to get the timing right would be impossible, but a flash trigger can be set to make the ultra-short flash exposure at the precise moment.

Triggering systems

There are lots of different triggering systems you can make or buy, and they come in a variety of forms. But the one thing they all share is their ability to respond to an event and trigger a flash. At this point it's worth noting that most high-speed shots are taken in either darkness or very low light, and despite appearing to utilize a split-second shutter speed, the opposite is actually true. The reason for shooting in darkness is that the ambient light is largely irrelevant—it is the ultra-short flash duration that freezes the subject, and this is most easily achieved when the shutter is open, so there is no lag while the mirror flips up.

In theory, a trigger can be constructed to respond to any event, as they are just relatively simple electronic devices that respond to a particular stimulus. However, the ones that are most useful for high-speed photography are those that respond to one of three inputs: contact,

sound, or movement. For example, a simple photogate trigger, such as the Schmitt trigger from hiviz.com/kits/spg.htm, contains just two parts: an emitter that sends out a beam of light, and a detector that receives the light. When the beam is broken, an electronic signal is sent and the flash is triggered.

To extend their usefulness, a trigger can be used in conjunction with a delay unit (the Schmitt Photogate-Delay Unit, for example) to compensate for the time it takes for the electronic signal to be sent from the trigger to the flash. These are especially useful when an identifiable trigger event will precede the actual moment you want to photograph. For example, a light-sensitive trigger can be placed to respond to a falling drop of water, but a momentary delay can be programed so the flash fires at the precise moment the drop strikes the surface, or the precise moment *after* it has struck.

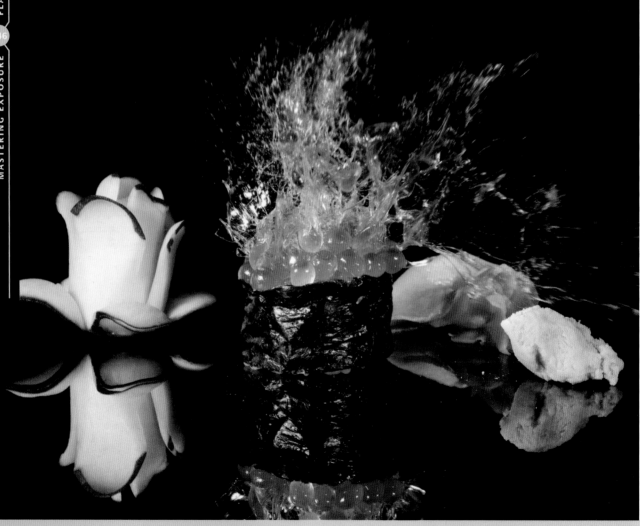

↓ 55mm, 1 second,
ƒ/14, ISO 320

↙ 105mm, 1 second,
ƒ/16, ISO 400
For this pair of images—
an optical trigger or an
audio trigger could be used.
It's largely a matter of trial

and error, but once you
learn the nuances of your
equipment, you can set
up a shot quite quickly.

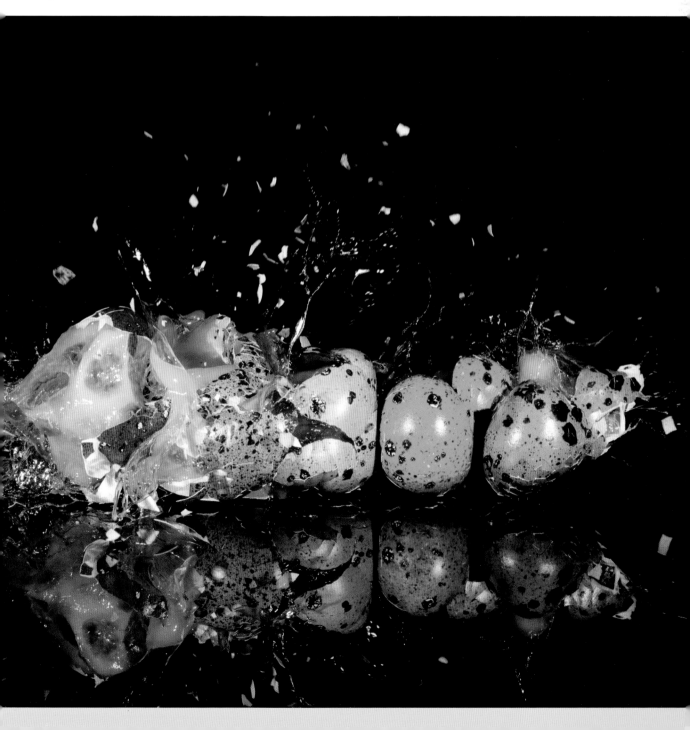

Audio triggers

With an event where sound—rather than movement—is the most important signifier of the "action" you want to photograph, an audio trigger can be the better option. As with a beam-based trigger, these can be used in conjunction with a delay timer, as shown in the images of a hammer breaking beer bottles. These were recorded using delays of 50 and 100 milliseconds between the sound registering and the flash firing. Although there is only a 1/20 second (50ms) difference between the two exposures, the content of each is very different, which demonstrates the usefulness of a trigger-delay.

Triggering systems might sound complicated, but the equipment you need is often very cheap. For example, the SPG1-DU Schmitt Photogate-Delay Unit—a beam-based trigger and delay unit—is all you would need to produce simple waterdrop shots, and it costs less than $20.00 in kit form. Assuming you already own a flash unit, this is something that could help you produce uniquely interesting shots at a very minimal cost.

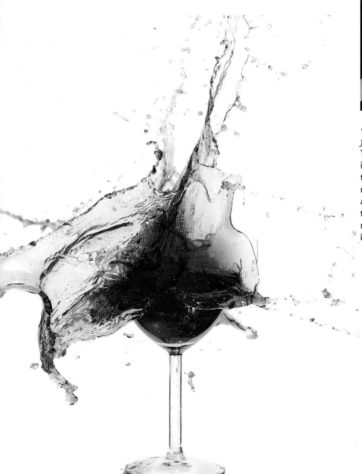

← 100mm, 5 seconds,
ƒ/13, ISO 100
To capture precise moments in time that are impossible to see with the eye, you can rely on serendipity or use a triggering system, but a trigger is the only way of making certain the effect is repeatable.

↑ 50mm, 10 seconds,
ƒ/5, ISO 200
This image demonstrates how an audio timer can be used in conjunction with a delay unit. Adjusting the delay between the signal and the flash firing can also create very different results from the same subject.

→ 100mm, 5 seconds,
ƒ/13, ISO 100
Although the shutter was open for 5 seconds, it is the ultra-fast burst of flash that provides the exposure in high-speed photography like this shot of an exploding water-filled balloon.

Shooting smoke

Although a motion or audio sensor is useful for some forms of high-speed photography, when it comes to the ethereal, abstract patterns of smoke, a trigger is unnecessary. This makes the technique very simple, although the results can be incredibly striking.

Working in a dimly lit room, start by setting up your camera on a tripod in front of your smoke source (incense sticks work well), with a black backdrop (card stock or velvet) behind. Position an off-camera flash to one side, or slightly behind the smoke source, and you're ready to go.

When it comes to choosing camera settings, you need to switch your camera to manual. You want to use a low ISO of 100–200 for optimum image quality, and set the shutter speed to the camera's maximum sync speed (1/200 second or 1/250 sec). Next, set a reasonably small aperture (f/8–f/16), so the depth of field is large enough to make sure the smoke will be as sharp as possible as it blows in front of the camera. Finally, set the focus manually, light your incense, and take a test shot with your flash set to full power.

You can now assess the exposure to see if your settings are working. The key here is not to change anything on the camera—it's your flash that you will use to increase or decrease the exposure. If the histogram shows your first shot is underexposed, move the flash closer to the smoke, or move it away from the smoke (or reduce its power) if your test shot is overexposed. You are aiming for a black (or near-black) background, where the lightest areas of the smoke do not appear as pure white.

Once you have a good histogram, you can start shooting for real. There's no need to look through the viewfinder as your camera's already set, so simply watch the smoke and shoot when it forms interesting shapes or patterns.

↑ 135mm, 1/180 second, f/11, ISO 100
A "raw" smoke shot should have detail in the lightest areas, and a black or near-black background. Use your camera's histogram to check your initial exposures, and once your settings are correct you can simply keep shooting as the smoke forms interesting shapes.

↗ 100mm, 1/200 second, f/11, ISO 100
You can enhance the abstract nature of smoke shots using your image-editing program. Here, I inverted the shot so the background changed from black to white, then used color adjustments to change the smoke from a drab gray into a more appealing copper-like color.

→ 70mm, 1/250 second, f/18, ISO 400
The way you post-process your smoke shots can be as subtle or as extreme as you like. In this shot, the smoke was rotated so it goes across, rather than up the frame, then it was inverted to create a white background. Finally, a rainbow effect was added, which results in an image that is as striking as it is abstract.

CHAPTER 5

SPECIAL EXPOSURE TECHNIQUES

"You don't take a photograph, you make it."
—Ansel Adams

In previous sections we discussed a broad range of techniques that can be used to create technically optical and aesthetically stunning images: ones that work equally well for the shortest of exposures on the brightest of days, through to shooting by the light of the stars on the darkest of nights. But there are some circumstances when these techniques are not enough. For example, when the dynamic range of the scene is extremely high, there's simply no way to capture a full range of tones in a single frame. In these cases you can either sacrifice the highlight detail, the shadow detail, or a portion of both, you can choose to come back later when the light is better, or you can choose to not take the shot.

In this section we're going to take a look at a range of techniques that allow you to transcend these limitations, particularly with respect to exposure, but also in terms of focus.

SHOOTING HIGH DYNAMIC RANGE SCENES

In the next few sections we're going to take a detailed look at how to overcome one of the problems we discussed in the opening chapter, i.e. when the dynamic range of a scene exceeds the dynamic range of your sensor. When shooting such a scene it's inevitable that either the shadows, highlights, or both will be clipped, but this is a problem that can be avoided by shooting a range of images that cover the entire dynamic range of the scene. You need to ensure that the darkest shot in your sequence contains no blown highlights, while the lightest contains no clipped shadows, and if you're going to process your files to create an HDR image, you should "fill in the gaps" between these exposures using either a 1 EV or 2 EV interval. For example, if you're shooting a scene where your darkest shot was taken at f/11 at 1/2000 second (to capture a full range of tones in the brightest areas of the scene) and your lightest was shot at f/11 at 1/60 second (to capture the shadow detail), you should also shoot an additional three frames: at 1/125, 1/500, and 1/1000 second.

→ This is a classic case for HDR: a bright, midday sky at the top of the frame, with dark foliage taking up most of the lower half. A graduated neutral density filter wouldn't quite work, as the gradation isn't precise enough. Instead, it's a simple matter of bracketing three exposures.

There's no hard and fast rule as to how many exposures you should shoot—it depends on the dynamic range of the scene—but it's fairly easy to work out how many frames you will need. The easiest way to do this is to switch to manual, set your camera to the metered exposure, and then gradually underexpose—one stop at a time—until you reach the exposure that will adequately capture the highlight detail. Once you've done this, note down the aperture and shutter speed and then repeat the process for the shadows, i.e. start at the metered exposure and gradually overexpose until you find the exposure that captures a full range of tones in the shadows. Again, note down the details. All you then need to do is start with the darkest exposure and then increase the exposure one stop at a time until you reach the lightest exposure.

HDR SHOOTING TIPS

Here are a few other things you should bear in mind:

Use a tripod: In what follows, we will be taking a look at how to combine your exposure sequence into a single image, and while there are ways of aligning multiple exposures with one another, these aren't always 100% reliable. If you shoot your original sequence using a tripod, taking care not to move the camera should you need to make any manual adjustments, your chances of creating a successful image will be much greater. If you have one, you should also use a remote release to further minimize the risk of moving the camera between shots.

Manual bracketing: If you do need to change your camera's setting manually make sure that you vary the exposure by altering the shutter speed, not the aperture or ISO. If you alter the aperture, you run the risk of the depth of field varying between exposures, and if you alter the ISO, each shot in the sequence will have varying amounts of noise.

Shoot quickly: If the scene you are recording doesn't contain any moving components then the speed at which you take your bracketed exposures doesn't matter—assuming, of course, that the lighting doesn't change during the sequence. If the scene contains rapidly moving components—people, birds, and so on—these cannot be recorded, at least not reliably. If, on the other hand, the scene contains slow moving components—clouds, for example—then the faster you shoot, the more likely they are to be in much the same place throughout the sequence.

Set your white balance: While I normally recommend using auto white balance for general shooting, it's a good idea to set a specific white balance when you're shooting a bracketed exposure sequence for HDR processing. The reason for this is because the light temperature may vary in different areas of the scene. For example, areas in bright sunlight may well be warm, so when you're shooting your darkest image auto white balance will skew the color temperature towards these warmer highlights because it can't "see" the cooler temperature in the shadows. By the same token, when you expose for the shadow detail and overexpose the highlights, again, your camera can't see the color temperature of the highlight so it skews the white balance towards the cooler tones in the darker areas of the scene. By switching to a specific white balance at the start of the sequence, you can avoid this problem from the outset.

HDR IMAGES & TONE MAPPING

Once you've shot your bracketed sequence of images, ensuring that you've captured a full range of tones in both the brightest and darkest areas of the original scene, you then need to combine them to create a single image. This can be done manually, as discussed in the next section, or you can automate the process using a number of programs such as Photoshop, Oloneo PhotoEngine, Photomatix Pro, and so on.

Before we take a look at both methods, it's worth noting that the problem we faced shooting a high dynamic range scene is one that we also face in displaying or reproducing one, i.e. much as the dynamic range of the original scene exceeded our camera's ability to capture it in a single frame, it's also way beyond what we can display in a print or on a conventional monitor. As such, we need to compress the dynamic range, either by manually combining one or more images, or by automating the process using one of the programs I mentioned above.

Before we discuss this second method, it's worth mentioning that the term "High Dynamic Range" (HDR) or "High Dynamic Range Image" (HDRI) is often used to label a particular style of picture, but technically, both labels are incorrect as an HDR image is an intermediate step in the process: it's a 32-bit file that contains the entire dynamic range of your original exposure sequence, and as such it cannot be displayed or printed on conventional Low Dynamic Range (LDR) devices or materials such as computer monitors or photographic paper. Once you've created your HDR image you then need to tone map it.

Tone mapping, at its simplest, is a method of compressing the data contained within the 32-bit HDR file, i.e. reducing the dynamic range to the level of a conventional image, but there are a variety of ways in which this can be done depending on the type of effect you want to achieve. For example, if your aim is to produce a photorealistic image—by which I mean one that could be perceived as a conventional photograph—then compressing the dynamic range of the HDR image in a linear manner may be your best option. Using this method is akin to squashing the data: the shadows will remain dark, the highlights will remain bright, but both will be rendered within a 16-bit or 8-bit workspace, leading to an image that can be displayed on a conventional monitor or printed. Photomatix Pro's Tone Compressor is a good example of this approach.

↓↘→ This bracket of three exposures (below, with their respective histograms) can generate an almost endless number of possible final images. The options shown on the opposite page are all presets using the HDR Efex Pro 2 software, and most HDR imaging software offers very similar readymade conversion options from which to choose. As you familiarize yourself with the software, you'll be able to predict which presets work best for a given type of shot—which is important, as the initial options available to you can be overwhelming.

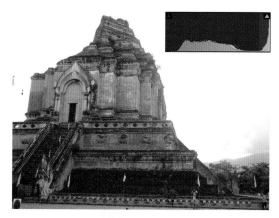

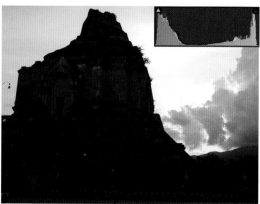

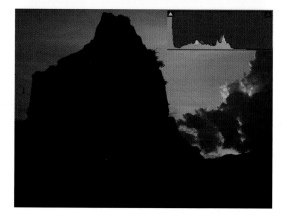

Deep

Bright

Structurized

Tinted

Granny's Attic

Soft

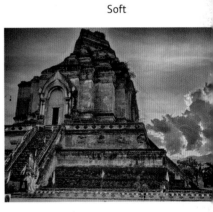

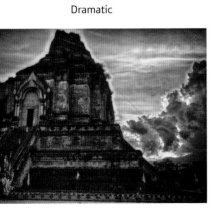

Dramatic

Pale & Structured

Outdoor

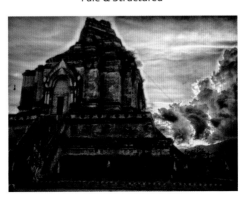

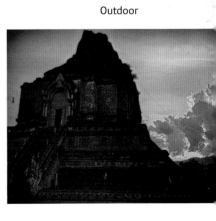

Late Summer

B&W Artistic

End of the Road

Most HDR programs, though, offer a range of alternative methods of tone mapping. For example, The Details Enhancer method within Photomatix Pro works by maximizing the tonal range within specific areas of an image, so, for example, there will be a high degree of contrast in sky, a wide distribution of tones in the foreground, and so on. This is one reason why it is crucial that your original exposure sequence captures both the shadow and highlight detail within an image, because if none of the shots in the sequence contains detail in the darkest areas of a scene, there will be no

detail in these areas in the final tone-mapped shot. Likewise, if all the shots in your sequence contain clipped highlights, this will also be incorporated into the final image. Typically, this method produces images that are much more easily recognized as "HDR images" and often have a distinctly surreal quality—but it's far from your only option. You can think of capturing these sequences of exposures as create an archive of the original light in the scene. That archive is chock full of information, but it will always require your own input to decide how to use it to create a finished image.

32-BIT WORKFLOW

The goal with this final interpretation of Wat Chedi Luang in Chiang Mai, Thailand was to accurately capture the feeling of this magnificent sunset, in a manner that doesn't strike the viewer as false. This is, in fact, easier said than done, and perhaps one of the reasons that hyperrealistic HDR images were so fashionable for a time is because it's quite a bit easier to simply export a preset than completely manipulate an image into a realistic and beautiful result. In any case, for this image, the traditional HDR software packages were ignored completely. Rather, using the Merge to HDR function in Photoshop, a 32-bit TIFF file was generated.

At first, it was very flat and low contrast. This is typical of a 32-bit HDR image file, and can be quite deceiving. The fact is, there is an abundance of tones in the file, but the monitor is unable to represent them all. But you'll quickly see the massive amount of information your working with when you start adjusting the sliders. There can be enormous amounts of detail hidden in the shadows and highlights, and these can all be adjusted quite precisely. For this image, the highlights were pulled back until the setting sun and clouds were as vivid as possible, and then the shadows were pushed up to bring out detail in the temple—but not too far. There still needs to be a certain degree of global contrast in order for the image to "read" as realistic.

→ It's important to recognize which shots will benefit from an HDR treatment. To a degree, you must learn to not trust your eyes, because they have a remarkable ability to scan discrete areas within your field of view and dynamically equalize them so the scene appears evenly illuminated.

This street scene, for instance, was a bright day, but the shadows cast on the ground mean there's no way all that dynamic range can squeeze into a single exposure. The solution was a quick three-image bracket, then a conversion to HDR, and a realistic tone mapping.

It's worth noting that that surreal HDR aesthetic has grown out of fashion in recent years. When the software first became widely available, the ability to compress such an enormous range of light into a single image led to wild exploration of the possibilities. For a while, it was hard to look at a single Flickr gallery without seeing dozens of hyper-realistic, super-saturated, surrealist interpretations of even the most mundane scenes. Now, there's nothing particularly wrong with enjoying this style of imagery—if you like it, feel free to explore your options. In fact, I'd say you should explore your options regardless of whether you like the particular style or not, because knowing what tools are available to you is a key to developing a professional skill set.

MANUAL EXPOSURE BLENDING

Manual exposure blending refers to merging two or more exposures into a single image, to either correct a problem with the tonal balance of a scene or to create an image from a bracketed sequence of shots from a scene where the dynamic range was too high to be adequately captured in a single image.

A good example of the former would be a landscape featuring an overly dark foreground offset against a much brighter sky. For this scenario, it would make sense to shoot two images, one exposed for the sky and the other for the foreground. In terms of the latter, exposure blending allows you to shoot scenes that can't be photographed in a single image. For example, it's a technique that is used quite extensively by interiors photographers who want to create an image that shows both the inside of a room in addition to the view through the windows. In these cases, the discrepancy in brightness between the two often makes it impossible to capture both in a single frame.

Shooting for exposure blending

As when shooting a bracketed sequence of images for HDR processing, it's much better to use a tripod for all the shots you'll be blending to make sure the content remains aligned between frames. It's also essential that you vary the shutter speed, not the aperture. Again, this ensures that the content within each of the frames you shoot will be the same.

There are two differences though between shooting for exposure blending and shooting for HDR. The first relates to white balance. In an earlier section, I mentioned that you should use a consistent white balance between frames when shooting for HDR, but this might not always be the case when you intend to manually blend a range of exposures. For example, if you're shooting two images of an interior—the room, and then the view through the windows—you need to make sure that the white balance you use for each is appropriate for the lighting. So, if the room is lit by tungsten light you should use tungsten WB (or incandescent) for the interior, and daylight for the outside. This will ensure that the lighting looks reasonably natural in both sections of the image.

The second difference is that movement within the scene may not be quite as problematic as it is when you're shooting a sequence for HDR. For HDR processing the data from each image is combined across the entire frame, but when you're manually blending exposures, this isn't the case. For example, if you're shooting a seascape—one exposure for the sky, the other for the sea—any movement in either

is largely irrelevant to the processing as you're only going to be using a section of each to construct the final image. Likewise, to go back to our example of shooting interiors, any movement beyond the window—maybe trees blowing in the wind, or cars passing by—will be captured in a single frame.

In each case, though, no matter what the subject matter, your starting point is to capture a range of frames that adequately capture a full range of tones in all the key areas of the scene. Once you've done that you're ready to blend the individual frames in Photoshop.

If you're opening the individual frames using Camera Raw you will need to open the images then copy and paste them into a single file. For example, if you have two frames, open the darker one first, then copy and paste the lighter one into this file. You will now have an image with two layers: the darker frame at the bottom of the layer stack, the lighter at the top. If you have more than two frames, simply repeat the process until all the images you need are stacked within one file.

If you have any concerns regarding their alignment with one another, you can align the layers from the Edit menu by selecting Auto Align Layers. This will present you with a range of alignment methods, but generally, the Auto option will do a good job of correcting any problems.

Once you've done this you then need to add a mask to the second layer, and any subsequent layers you added. This can be done from the Layer menu by selecting either Layer Mask > Reveal All or Layer Mask > Hide All. If the section you want to blend from the first image is small then the latter would make more sense, i.e. hide all of the layer then erase the mask to reveal the small section.

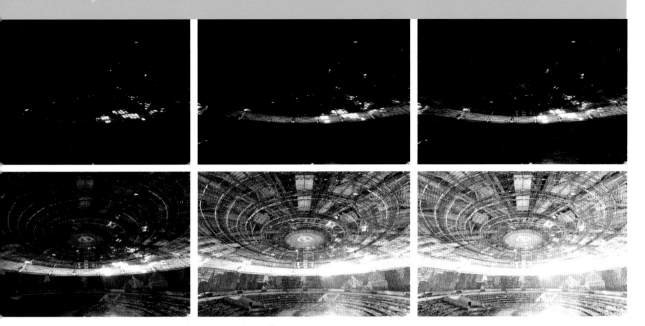

↑↓ The exposures run from −5EV at the top left to +2EV at the bottom right (I was more interested in capturing plenty of shadow detail, as that's where a lot of the detail would be and I didn't want it too noisy). Assembling all the layers in

Photoshop can slow down all but the most well-equipped computers, but the result is often quite exquisite.

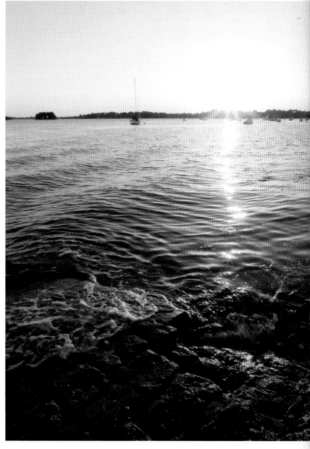

Masking techniques

Creating a convincing mask—one that will seamlessly blend one frame with another—can be time-consuming, and it's a technique that you'll definitely need to practice if you haven't done it before. The key thing you need to bear in mind is that the join between the different frames—where one exposure meets another—must never be visible. Your aim is to create a plausible image, not one that looks like it was Photoshopped. To do this your mask needs to be either absolutely precise, or the join must be feathered (or blended) in such a way that one image fades into the other in a convincing manner.

A good example of the latter would be a seascape, i.e. you could use a gradient mask to blend the darker shot of the sky with the brighter shot of the sea. In fact, in this instance, trying to create a very precise mask along the horizon would look very unnatural, as the sea at the horizon would appear too dark in comparison to the sky. In this case, you need to gently blend one frame with the other.

For shots where the natural joins between different areas of the image are a feature of the scene, you'll need to ensure that your mask is precise. A good

↖↑→ Here, the exposure was simple enough to blend, but the water was quite fast moving and changed considerably netween the two exposures. The overlapping waves in the foreground had to be cloned away as it showed up as an obvious double exposure. In the midground of the sun reflecting on the surface of the water, however, some of both frames were includes—starbursts from the brighter exposure and smoother tonalities from the darker one. The sky was all from the darker exposure, and so the brighter one was completely masked out.

example of this would be the interior shot we mentioned earlier. Here, the join between the different areas is a very precise one—the edge of the window frame as it meets the glass—so your mask would need to be equally precise in order to seem convincing.

Once you have blended your images to create a believable image—one that portrays the entire tonal range of the original scene in a convincing way—you can then move on to process it much as you would any other image.

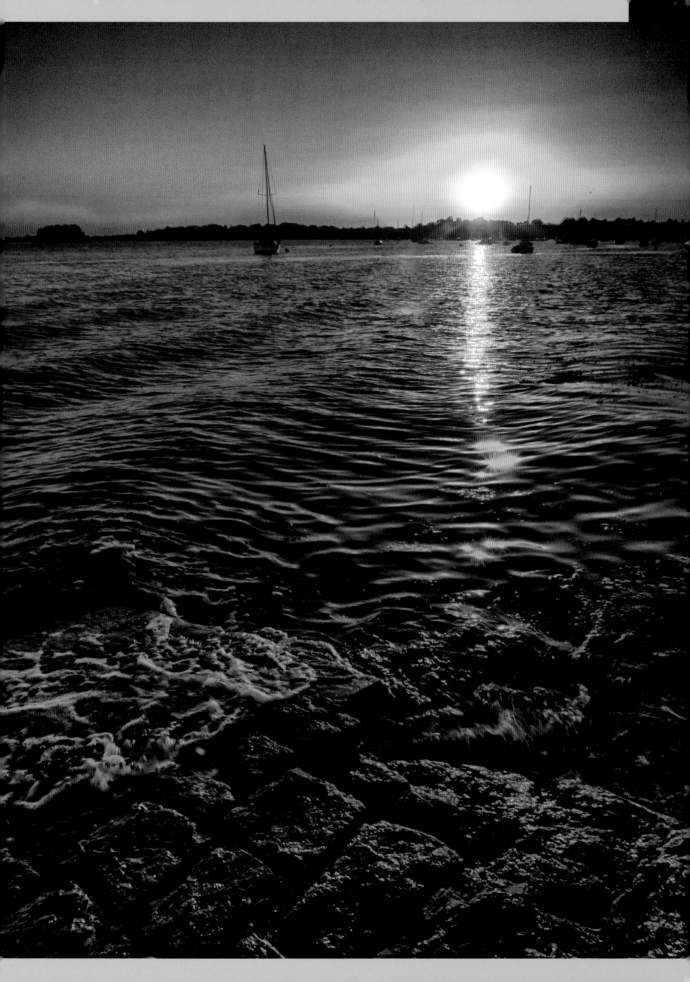

FOCUS STACKING

The closer you focus to the camera, the shallower your depth of field becomes, and with macro photography this can mean the depth of field may only cover an inch at the smallest aperture setting. However, there is a way that you can work around this common problem, using a software-based solution known as "focus stacking."

Just as HDR photographs are constructed by shooting a range of exposures, so focus stacking also starts with a sequence of images. However, instead of the exposure changing from shot to shot, the point of focus is changed. The sequence is then combined—or

"stacked"—to create a final result that uses the sharp, in-focus elements of each picture to create the effect of a much larger depth of field.

There are a number of benefits to this approach, not least that you can create images that are simply not possible with a conventional lens, even when shooting using its smallest aperture. You can also maximize the quality of the final image by shooting at your lens' optimum aperture, and this also means you can shoot a sequence of images using a faster shutter speed, rather than a single, long exposure that might increase noise.

← Taken using an aperture setting of $f/32$—the smallest aperture available on my Canon 100mm macro lens—the front of the bracelet is sharp, but the focus falls off toward the rear of the image.

← For this picture, a sequence of images were taken at an aperture setting of $f/11$— the lens' optimum aperture. Focusing at different points and then "stacking" the images creates a much greater depth of field, and the entire bracelet is now sharply focused.

→ The six shots used to create the final bracelet image were all taken with an aperture of *f*/11. The point of focus was changed for each shot, allowing some overlap, so, when the images were stacked, the whole bracelet would appear sharply focused.

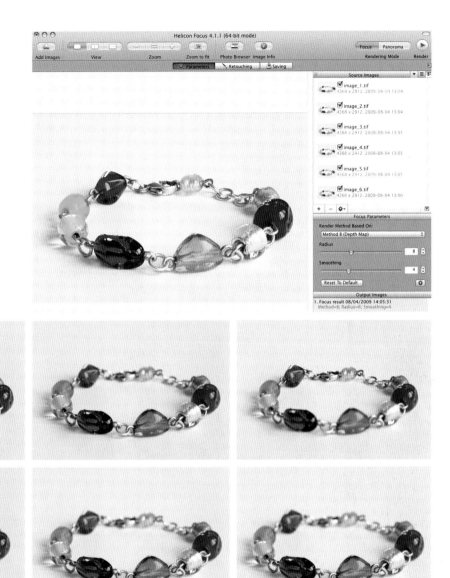

The shot of the bracelet shown here was constructed using Helicon Focus (www.heliconsoft.com), an affordable program for both Mac and PC. But before you can stack your images you need to shoot them, and there are three things you should bear in mind. First, you should aim to keep your camera as steady as possible between exposures, so it's a good idea to use a tripod and remote release. Second, you should start with either the near point or the far point of focus, and work to the opposite extreme—don't start in the middle. Finally, and most importantly, you should aim to shoot enough images so that each part of the subject is sharp in at least one of the photographs. There will be some guesswork involved in this as it's difficult to judge the depth of field in each shot as you take your sequence. If you are in any doubt, shoot more images than you think you will need. For this bracelet image, six photographs taken at *f*/11 were enough to ensure every part of the bracelet was sharp in at least one of the frames.

Once you have shot your sequence of images you can import them into Helicon Focus using the "Add Images" button, or the File menu (File > Add Images). You can then combine them using Tools > Render and if the original sequence doesn't pose any problems for the software, you're done—all you need to do is click Save!

Focus parameters

If your initial render is less than perfect, there are three focus parameters in Helicon Focus that might help improve the final result. The first of these is the Render Method. Method A (Weighted Average) calculates the contrast of each pixel, while Method B (Depth Map) creates a depth map based on the sharpest pixels within one of the images. Generally, both of these work equally well, with little, if nothing, to tell them apart. However, if one produces a poor result, it is worth trying the other. The second change you can make is to the Radius. The default value normally produces good results, but images with fine detail can benefit from a lower setting (a value of 3–6), while images with coarser detail might require a higher setting (a value of 10–15).

Finally, you can adjust the Smoothing, which determines how the data from the images is combined. A low level can increase sharpness (but introduce artifacts) in the final picture, while a higher value will give a more seamless result, but with the possibility of some additional blur.

The limitations of focus stacking

While focus stacking works well with motionless subjects, it will struggle when parts of a scene move between frames—a landscape that contains trees or flowers blowing in the wind, or water, for example. Combining the initial sequence can be much harder, and in some cases it is simply impossible to achieve the desired result without heavy cloning in an image-editing program.

Focus-stacking software can also struggle when there are abrupt transitions in the plane of focus, such as a greater distance between the foreground and background elements. The reason for this is there is always a slight shift in the *size* of in-focus and out-of-focus elements in an image, and the greater the distance between the elements, the greater the size difference. This can mean that a defocused element in one shot appears larger in the frame than it does when it is sharply in focus in another frame. As the above image shows, this can create an unusual blurred edge when the image sequence is stacked.

← The pole changed size depending on whether it was in or out of focus in this shot. As a result, the right edge exhibits a blurring artifact when the focus sequence is combined.

→ The initial sequence for this shot consisted of ten images, taken at $f/7.1$. Focus stacking was necessary to get all of the petals and branches in clean focus.

REFERENCE

GLOSSARY

Adobe
A software company whose products include Photoshop and Lightroom

aliasing
The jagged appearance of diagonal lines in an image, caused by the square shape of pixels.

anti-aliasing
The smoothing of jagged edges on diagonal lines created in an imaging program, by giving intermediate values to pixels between the steps.

aperture
The opening behind the camera lens through which light passes on its way to the image sensor (CCD/CMOS).

artifact
A flaw in a digital image.

aspect ratio
The ratio between the width and height of an image. Traditional television has an aspect ratio of 4:3, 35mm film is 3:2, and wide-screen television is 16:9.

auto exposure
Letting the light meter in the camera determine which shutter time and aperture should be used for a given scene.

auto focus
When using automatic focus, the subject in front of the camera lens is brought into focus by letting the camera determine when the subject is sharpest.

banding
Unwanted effect in a tone or color gradient in which bands appear instead of a smooth transition. It can be corrected by higher resolution and more steps, and by adding noise to confuse that part of the image.

bayonet fitting
A quick-release fitting to attach a lens to a camera, common on all EVIL cameras. The alternative is a screw fitting.

backlighting
The result of shooting with a light source, natural or artificial, behind the subject to create a silhouette or rim-lighting effect.

Bézier curve
A curve described by a mathematical formula. In practice, it is produced by manipulating control handles on a line that is partly held in place by anchor points.

bit (binary digit)
The smallest data unit of binary computing, being a single 1 or 0.

bit depth
The number of bits of color data for each pixel in a digital image. A photographic-quality image needs eight bits for each of the red, green, and blue channels, making for a bit depth of 24.

bracketing
A method of ensuring a correctly exposed photograph by taking three shots; one with the supposed correct exposure, one slightly underexposed, and one slightly overexposed.

brightness
The level of light intensity. One of the three dimensions of color in the HSB color system. See also Hue and Saturation.

byte
Eight bits. The basic unit of desktop computing. 1,024 bytes equals one kilobyte (KB), 1,024 kilobytes equals one megabyte (MB), and 1,024 megabytes equals one gigabyte (GB).

calibration
The process of adjusting a device, such as a monitor, so that it works consistently with others, such as scanners and film recorders.

catchlight
A catchlight is a small dot of white in somebody's eye—it gives your model a "glint" in the eye that often makes a photo look more natural than if it were omitted.

CCD (Charge-Coupled Device)
A tiny photocell used to convert light into an electronic signal. Used in densely packed arrays, CCDs are used as imaging sensor in most compact cameras.

channel
Part of an image as stored in the computer; similar to a layer. Commonly, a color image will have a channel allocated to each primary color (e.g. RGB) and sometimes one or more for a mask or other effects.

cloning
In an image-editing program, the process of duplicating pixels from one part of an image to another.

CMOS (Complementary Metal-Oxide Semiconductor)
An alternative sensor technology to the CCD, using an energy-saving design of semiconductor that uses two circuits of opposite polarity. Pioneered in digital cameras by Canon.

CMS (Color Management System)
Software (and sometimes hardware) that ensures color consistency between different devices, so that at all stages of image-editing, from input to output, the color balance stays the same.

color gamut
The range of color that can be produced by an output device, such as a printer, a monitor, or a film recorder.

color model
A system for describing the color gamut, such as RGB, CMYK, HSB, and lab.

color separation
The process of separating an image into the process colors cyan, magenta, yellow, and black (CMYK), in preparation for printing.

color space
A model for plotting the hue, brightness, and saturation of color.

color temperature
A way of describing the color differences in light, measured in Kelvins and using a scale that ranges from dull red (1900 K), through orange, to yellow, white, and blue (10,000 K).

compression
Technique for reducing the amount of space that a file occupies, by removing redundant data. There are two kinds of compression: standard and lossy. While the first simply uses different, more processor-intensive routines to store data than the standard file formats (see LZW), the latter actually discards some data from the image. The best known lossy compression system is JPEG, which allows the user to choose how much data is lost as the file is saved.

contrast
The range of tones across an image, from bright highlights to dark shadows.

cropping
The process of removing unwanted areas of an image, leaving behind the most significant elements.

cut-and-paste
Procedure in graphics for deleting part of one image and copying it into another.

depth of field
The distance in front of and behind the point of focus in a photograph, in which the scene remains in acceptable sharp focus.

diffusion
The scattering of light by a material, resulting in a softening of the light and of any shadows cast. Diffusion occurs in nature through mist and cloud cover, and can also be simulated using diffusion sheets and soft-boxes.

digital
A way of representing data as a number of distinct units. A digital image needs a very large number of units so that it appears as a continuous-tone image to the eye; when it is displayed these are in the form of pixels.

digital zoom
Many cheaper cameras offer a digital zoom function. This simply crops from the center of the image and scales the image up using image processing algorithms (indeed the same effect can be achieved in an image editor later). Unlike a zoom lens, or "optical zoom," the effective resolution is reduced as the zoom level increases; 2× digital zoom uses ¼ of the image sensor area, 3× uses √₉, and so on. The effect of this is very poor image quality; Even if you start with an eight megapixel sensor, at just 3× digital zoom your image would be taken from less than one megapixel of it.

digitize
To convert a continuous-tone image into digital form that a computer can read and work with. Performed by a scanner.

dye sublimation printer
A color printer that works by transferring dye images to a substrate (paper, card, etc.) by heat, to give near photographic-quality prints.

dynamic range
The range of tones that an imaging device can distinguish, measured as the difference between pure black and pure white. It is affected by the sensitivity of the hardware and by the bit depth.

edge lighting
Light that hits the subject from behind and slightly to one side, creating flare or a bright "rim lighting" effect around the edges of the subject.

extension tube
A mechanical device that allows a lens to be held securely in place a distance away from the camera body.

file format
The method of writing and storing information (such as an image) in digital form. Formats commonly used for photographs include TIFF, BMP, and JPEG.

fill-in flash
A technique that uses the on-camera flash or an external flash in combination with natural or ambient light to reveal detail in the scene and reduce shadows.

fill light
An additional light used to supplement the main light source. Fill can be provided by a separate unit or a reflector.

filter
(1) A thin sheet of transparent material placed over a camera lens or light source to modify the quality or color of the light passing through. (2) A feature in an image-editing application that alters or transforms selected pixels for some kind of visual effect.

focal length
The distance between the optical center of a lens and its point of focus when the lens is focused on infinity.

focal range
The range over which a camera or lens is able to focus on a subject (for example, 0.5m to Infinity).

focus
The optical state where the light rays converge on the film or CCD to produce the sharpest possible image.

frame grab
The electronic capture of a single frame from a video sequence. A way of acquiring low-resolution pictures for image-editing.

fringe
A usually unwanted border effect to a selection, where the pixels combine some of the colors inside the selection and some from the background.

frontal light
Light that hits the subject from behind the camera, creating bright, high-contrast images, but with flat shadows and less relief.

f-stop
The calibration of the aperture size of a photographic lens.

gamma
A measure of the contrast of an image, expressed as the steepness of the characteristic curve of an image.

GB (GigaByte)
Approximately one billion bytes (actually 1,073,741,824).

GIF (Graphics Interchange Format)
Image file format developed by Compuserve for PCs and bitmapped images up to 256 colors (8-bit), commonly used for Web graphics.

global correction
Color correction applied to the entire image.

grayscale
An image made up of a sequential series of 256 gray tones, covering the entire gamut between black and white.

golden hour
The hour just after sunrise or just before sunset, so named after the warm quality of the sunlight.

halogen bulb
Common in modern spotlighting, halogen lights use a tungsten fillament surrounded by halogen gas, allowing it to burn hotter, longer and brighter.

HDRI (High Dynamic Range Imaging)
A method of combining digital images taken at different exposures to draw detail from areas which would traditionally

have been over or under exposed. This effect is typically achieved using a Photoshop plugin, and HDRI images can contain significantly more information than can be rendered on screen or even percieved by the human eye.

histogram
A map of the distribution of tones in an image, arranged as a graph. The horizontal axis goes from the darkest tones to the lightest, while the vertical axis shows the number of pixels in that range.

HSB (Hue, Saturation, Brightness)
The three dimensions of color, and the standard color model used to adjust color in many image-editing applications.

hue
The pure color defined by position on the color spectrum; what is generally meant by "color" in lay terms.

image file format
The form in which an image is handled and stored electronically. There are many such formats, each developed by different manufacturers and with different advantages according to the type of image and how it is intended to be used. Some are more suitable than others for high-resolution images, or for object-oriented images, and so on.

inkjet
Printing by spraying fine droplets of ink onto the page; by some distance the most common home printing technology.

interpolation
Bitmapping procedure used in resizing an image to maintain resolution. When the number of pixels is increased, interpolation fills in the gaps by comparing the values of adjacent pixels.

ISO
An international standard rating for film speed, with the film getting faster as the rating increases. ISO 400 film is twice as fast as ISO 200, and will produce a correct exposure with less light and/or a shorter exposure. However, higher-speed film tends to produce more grain in the exposure, too.

JPEG
(Joint Photographic Experts Group)
Pronounced "jay-peg," a system for compressing images, developed as

an industry standard by the International Standards Organisation. Compression ratios are typically between 10:1 and 20:1, although lossy (but not necessarily noticeable to the eye).

KB (KiloByte)
Approximately one thousand bytes (actually 1,024).

LCD (Liquid Crystal Display)
Flat screen display used in digital cameras and some monitors. A liquid-crystal solution held between two clear polarizing sheets is subject to an electrical current, which alters the alignment of the crystals so that they either pass or block the light.

lossless
Type of image compression in which no information is lost, and so most effective in images that have consistent areas of color and tone. For this reason, not so useful with a typical photograph.

lossy
Type of image compression that involves loss of data, and therefore of image quality. The more compressed the image, the greater the loss.

luminosity
Brightness of color. This does not affect the hue or color saturation.

mask
A grayscale template that hides part of an image. One of the most important tools in editing an image, it is used to make changes to a limited area. A mask is created by using one of the several selection tools in an image-editing program; these isolate a picture element from its surroundings, and this selection can then be moved or altered independently.

MB (MegaByte)
Approximately one million bytes (actually 1,048,576).

megapixel
A rating of resolution for a digital camera, directly related to the number of pixels forming or output by the CMOS or CCD sensor. The higher the megapixel rating, the higher the resolution of images created by the camera.

mid-tone
The parts of an image that are approximately average in tone, falling midway between the highlights and shadows.

modeling light
A small light built into studio flash units which remains on continuously. It can be used to position the flash, approximating the light that will be cast by the flash.

noise
Random pattern of small spots on a digital image that are generally unwanted, caused by nonimage-forming electrical signals.

noise filter
Imaging software that adds noise for an effect, usually either a speckling or to conceal artifacts such as banding.

photo-composition
The traditional, non-electronic method of combining different picture elements into a single, new image, generally using physical film masks.

plugin module
Software produced by a third party and intended to supplement a program's performance.

pixel (PICture ELement)
The smallest units of a digital image, pixels are the square screen dots that make up a bitmapped picture. Each pixel carries a specific tone and color.

PNG (Portable Network Graphic)
A file format designed for the web, offering compression or indexed color. Compression is not as effective as JPEG.

ppi (pixels-per-inch)
A measure of resolution for a digital image.

RAM (Random Access Memory)
The working memory of a computer, to which the central processing unit (cpu) has direct, immediate access.

Raw
A digital image format, known sometimes as the "digital negative," which preserves higher levels of color depth than traditional 8 bits per channel images. The image can then be adjusted in software—potentially by three f stops—without loss of quality. The file also stores camera data including

meter readings, aperture settings and more. In fact each camera model creates its own kind of Raw file, though leading models are supported by software like Adobe Photoshop.

resampling
Changing the resolution of an image either by removing pixels (lowering resolution) or adding them by interpolation (increasing resolution).

resolution
The level of detail in a digital image, measured in pixels (e.g. 1,024 by 768 pixels), or dots-per-inch (in a half-tone image, e.g. 1200 dpi).

RGB (Red, Green, Blue)
The primary colors of the additive model, used in monitors and image-editing programs.

rim-lighting
Light from the side and behind a subject which falls on the edge (hence rim) of the subject.

saturation
The purity of a color, going from the lightest tint to the deepest, most saturated tone.

scanner
Device that digitizes an image or real object into a bitmapped image. Flatbed scanners accept flat artwork as originals; slide scanners accept 35mm transparencies and negatives; drum scanners accept either film or flat artwork.

selection
A part of the on-screen image that is chosen and defined by a border, in preparation for making changes to it or moving it.

shutter
The device inside a conventional camera that controls the length of time during which the film is exposed to light. Many digital cameras don't have a shutter, but the term is still used as shorthand to describe the electronic mechanism that controls the length of exposure for the CCD.

shutter speed
The time the shutter (or electronic switch) leaves the CCD or film open to light during an exposure.

SLR (Single Lens Reflex)
A camera that transmits the same image via a mirror to the film and viewfinder, ensuring that you get exactly what you see in terms of focus and composition.

soft-box
A studio lighting accessory consisting of a flexible box that attaches to a light source at one end and has an adjustable diffusion screen at the other, softening the light and any shadows cast by the subject.

spot meter
A specialized light meter, or function of the camera light meter, that takes an exposure reading for a precise area of a scene.

stylus
Penlike device used for drawing and selecting, instead of a mouse. Used with a graphics tablet.

subtractive primary colors
The three colors cyan, magenta, and yellow, used in printing, which can be combined to create any other color. When superimposed on each other (subtracting), they produce black. In practice a separate black ink is also used for better quality. See also rgb and additive primary colors

sync cord
The electronic cable used to connect camera and flash.

telephoto
A photographic lens with a long focal length that enables distant objects to be enlarged. The drawbacks include a limited depth of field and angle of view.

thumbnail
Miniature on-screen representation of an image file.

TIFF (Tagged Image File Format)
A file format for bitmapped images. It supports cmyk, rgb and grayscale files with alpha channels, and lab, indexed-color, and it can use LZW lossless compression. It is now the most widely used standard for good-resolution digital photographic images.

TTL (Through The Lens)
Describes metering systems that use the light passing through the lens to evaluate exposure details.

umbrella
In photographic lighting, umbrellas with reflective surfaces are used in conjunction with a light to diffuse the beam.

wide-angle
Type of lens with a short focal length, lenses are characterized by a wide depth of field.

white balance
A digital camera control used to balance exposure and color settings for artificial lighting types.

wysiwyg
(what you see is what you get)
Pronounced "wizzywig," this acronym means that what you see on the screen is what you get when you print the file.

zoom
A camera lens with an adjustable focal length, giving, in effect, a range of lenses in one. Drawbacks include a smaller maximum aperture and increased distortion over a prime lens (one with a fixed focal length).

INDEX

PICTURE CREDITS

The publisher would like to thank the following indviduals for their kind permission to reproduce their images in this book. Every effort has been made to acknowledge the pictures. However, we apologize if there are any omissions.

Attem: 58
Jon Bilous: 95T
Mooin Black: 57
Miles Boyer: 148
Phil Daint: 90
Nikonchyk Darya: 56
Claudio Divizia: 84
R Donar: 40
Dubova: 106
Durden Images: 123
M R Fiza: 103T
Florida Stock: 145
Frank Gallaugher: 14, 18, 27, 28, 29, 31, 33, 34, 35, 47, 111, 122, 126, 127, 155, 156, 157, 158, 159, 162, 163, 176
Matt Gibson: 125
Pavel GR: 23
Hergon: 131, 140
IndustryAndTravel: 94
iStockphoto.com: 16–17, 25B, 25, 63, 69, 70, 71, 75, 78–79, 80, 82, 88, 102, 103B, 121, 128, 141, 148L, 149, 150, 151B
JPL Designs: 83
Kasaba: 59
Alex Malikov: 137
Dudarev Mikhail: 81
MountainHardcore: 44
Macbrian Mun: 97T
Narathip: 95B
David Nightingale: 7, 9, 15, 21, 22, 24, 25T, 37, 42, 48, 49, 50, 51, 53, 55, 62, 62, 64, 65, 66, 72, 73, 74, 76, 86. 87, 89, 96, 97B, 98, 105, 113, 114, 115, 116, 117, 118, 129, 133, 135, 136, 151T, 153, 161, 164, 165, 166
Ondrej83: 93T
Maxim Petrichuk: 101
PhotoHouse: 107
Keith Pytlinski: 138–139
Valentina Razumova: 109
Tamil Selvam: 93B
Julie She: 39
Ryan Jack Taylor: 146–147
Toa55: 119
TonyV3112: 100
Lee Yiu Tung: 84
Jasper van der Meij: 142–143
Dennis van de Water: 144
Petri Volanen: 91
Blair Wacha: 167